THE
ANTI-SOCIAL CONTRACT

Y. N. KLY

CLARITY

Cataloging in Publication Data:

Kly, Yussuf Naim
 The anti-social contract

Includes bibliographical references
ISBN 0-932863-09-4

1. Minorities--Legal status, laws, etc.--United States. I. Title.

JK271.K49 1989 342.78'0873 C89-090265-8

CLARITY PRESS, INC.
Suite 469, 3277 Roswell Rd. N.E.
Atlanta, GA. 30305, USA

and

CLARITY INTERNATIONAL
P.O. Box 3144
Windsor, Ont. N8N 2M3, Canada

TABLE OF CONTENTS

FOREWORD

The written portion of an agreement or contract need not necessarily be the entire agreement or contract itself, but rather one evidence that the contract or agreement exists, and one evidence of the nature of that agreement. To find the entire contract or agreement, it is sometimes necessary to review many written evidences, as well as to often reconstruct the various circumstances of the situation and circumstances in order to correctly interpret the existing written evidences.

Similarly, the social contract that serves to legitimize the establishment of the U.S. government must be found not only in the Constitution, but also in the laws that sanctioned slavery and the settlers' right to land once used by the Native Americans, in the Jim Crow laws, the laws that legitimized segregation, the Civil Rights Laws, etc., and most recently, the legal principles and court rulings that prevented quotas or an effective affirmative action program to overcome the present result of past injuries.

In 1776, the representatives of the American colonists produced a written Constitution that was both acceptable to and accepted by the vast majority of Anglo-American colonists. It was a written social contract that highlighted the evolution of the European mind towards liberal democratic freedom, and it was a social contract that included the best of concepts from Plato, Roman Stoicism, John Locke, Thomas Hobbes, John Stewart Mills, Jean-Jacques Rousseau, etc.. It was truly an amazing politico-literary document, and it would serve as the basis for legitimizing the government of what has come to be known as mankind's most fabulous experiment in liberal democratic freedom: the United States of America. Indeed, the U.S. Constitution (the written portion of its social contract) did establish a government of the Anglo-Americans, for the Anglo-Americans and by the Anglo-Americans.

However, before we blow our horn, and begin our mouthing of unending praises to God Almighty for the U.S. Constitution, there is one significant fact that must be incorporated into any sincere scientific analysis: when the U.S. Constitution was written, more than 50%

of the population over which it was to eventually serve as the basis for legitimate government was non-Anglo-American and non-European, and thus, non-participant in its formation.

Allan Bloom, in *The CLosing of the American Mind,* completely misses this point (the essence of constitutional democracy in a multi-national state), when he writes:

> The Constitution was not just a set of rules of government but implied a moral order that was to be enforced throughout the entire union... The dominant majority gave the country a dominant culture with its traditions, its literature, its facts, its special claim to know and supervise language and its protestant religions... The American revolution instituted this system of government for Americans, who in general were satisfied with the result and had a pretty clear view of what they had done. The question of political principle and of right had been solved once and for all... For some Europeans, America represented an intolerable narrowing of the human horizon and the price paid for their decency, order and prosperity was too high... {could} private property and equality sit so easily together when even Plato required communism among equals? Communism or socialism never really made much headway against the respect for private property in the United States.[1]

Well, we say, we know that, yes! But do we commit the sacrilege of making it an independent variable in our otherwise scholarly analysis? No! For such analysis would necessarily suggest, apart from the written portion of the social contract (the U.S. Constitution), there is an unwritten portion, which for lack of a better word we may call the anti-social contract, which determines the significant political relation between the white American majority ethny and the minority ethnies or nations that it governs.

True, this was not written anywhere in the Constitution. Rather, it was accomplished through Constitutional omission, by not having the Africans and Native Americans represented in the formulation of the Constitution, by not mentioning in the document that slavery of Africans was not acceptable, by speaking as if all Americans were equal and free as they were when obviously some were in chains, and thus leaving open the possibility for an unwritten agreement which accepted the popular notion of the time that Africans and other non-Europeans were not completely human, did not deserve the same rights, were too ignorant or non-Christian to have civilized rights, etc..

These are some of the notions that served as the basis for the unwritten portion of the U.S. social contract which in this book we

have chosen to refer to as the anti-social contract. Among the African-Americans, it has always been known as the unwritten rules. The Native American conceptualized the anti-social contract in the expression: white man speaks with forked tongue.

The most stereotypical example of this phenomenon of a viable social and anti-social contract intermingled can be seen in India, South Africa, and, before its collapse, the Algeria of the *pieds noirs.* In each case, the gap between the actual policies and practices of the government in relation to a significant ethnic segment of its population and its democratic constitution/values (often copied from that of the U.S.) are related only in the sense that the constitutional values are used by dominant Aryans or white ethnies to galvanize the unity of the dominant ethny and its allies for the purpose of maintaining the oppression of the non-Aryan or non-white ethny - and of course, providing the socio-legal basis for their unequal position in the society to be explicable in relation to their lack of education, inappropriate family life, lack of religious training, etc... any and every feasible thing except their oppression. Of course, the proposed solution is always the same: more education... more of the same domination, more oppression, and eventually the non-Aryan or non-white ethny's knowledge of its collective identity will simply cease to exist and everyone will live happily everafter.

The U.S. experiment with the anti-social contract is perhaps the most successful. The rapid development of the U.S. and its assistance to the ruling European nations despite its internal contradictions have led to widespread international acceptance of its illusion of socio-cultural success. However, the cost of maintaining the anti-social contract has caused unacceptable damage to the American educational system, America's cities, its morale and morality, its self-image, foreign-policy orientation, and sense of well-being and happiness.

And now we must begin the process of rendering this anti-social contract null and void or writing a new social contract. The first step is to open the eyes of America to its existence by highlighting some of its historical components. This book attempts to begin this step. The final step will be the restructuring of the politico-legal system so as to encourage the emergence of the force that will render the anti-social contract null and void. This we hope will be the subject of future research. However, like the paradox of siamese twins, the social contract will be lost unless it can be separated from the anti-social contract.

When an exposé of an actual U.S. institution is presented, there is often the claim that the point of view presented results from and is controlled by a bias which itself is either impractical or represents a political theory socio-politically less desirable or acceptable than the U.S. institution it proposes to criticize. It is often pointed out that such criticism is not motivated by a search for truth, but rather is blindly and emotionally motivated by such ideologies as black nationalism, the desire for a black or Islamic state, or to promote payment of reparations, or the establishment of quotas or the victory of a communist/socialist revolution, or a back to Africa movement, etc.. Regardless of our feeling about any of the aforementioned ideologies and goals, we can with absolute sincerity say that this writing is motivated solely by our desire to open a real dialogue on the question of U.S. minority rights and conditions -- a sincere dialogue that is long overdue, a dialogue that has historically been effectively blocked by the blind adherence to U.S. clichés and myths about its political system, about its all-seeing and all-knowing perfect democratic Constitution, about its founding on the dream of riches, freedom and equality for all men, about its adherence to the will of God, about U.S. justice being color blind, about there being no ethnic minorities but instead one big melting pot in which everyone is really just an American like everyone else, and the only thing that counts is one's ability, education and money; that the U.S. is better than and morally superior to all other countries, etc..

> America, oh America
> Land of the Free
> Home of the brave
> Executioner of the Indian
> Master of the slave
> This message of thee
> Sweet land of liberty.

PART ONE

CONTRACTS, SOCIAL AND ANTI-SOCIAL

INTRODUCTION

The actual informal agreement or contract between Anglo-Americans which determines the U.S. government relationship with the African-American/Native American minorities[2] is not only different from the ideal model of a social contract formulated by social philosophers of the 18th century which subsequently provided the theoretical legitimacy for governments in modern democratic states, but in most cases, it is the opposite. This was probably also the case with all national minorities (natives) living in colonial territories before the de-colonization process of the 60's, etc., and in effect this opposite model, this anti-social contract, was, judicially speaking, probably a necessary and sufficient component of the colonial and imperialistic arrangements.

It is probable that both colonialism and economic imperialism can exist wherever the arrangement or the association between the government and its national minorities exhibits the qualities of an anti-social contract. Territorial separation, while politically expedient, is probably not necessary. This can be shown by documenting that all necessary elements of imperialism or colonialism (except territorial separation) can exist within the anti-social contract arrangement: inequality, exploitation and domination. Of course, if this is true, the territorial question presently so important to the definition of colonialism is largely irrelevant. The heart of the problem (since the anti-social contract can be forced on nationalities or minorities sharing the same land mass) is that does inequality, exploitation and domination exist?

Our purpose is to suggest that the U.S. minority policy is based on an anti-social contract and that the historic enactment of this anti-

social orientation in regard to the African-American/Native American minorities, etc. has led to heightened racism and white nationalism in the modern world.[3] In the following chapter, we will present a summary restatement of the principles of the social contract ideal or model as it would logically relate to the situation of minorities living in multi-national states. These ideals will help distinguish the vast difference between a true liberal democratic formula for the legitimization of democratic government, and concepts practiced in the U.S. in relation to its minorities. The purpose is to suggest that in dealing with its minorities, the U.S. has not employed the liberal democratic methods of legitimizing its right to govern, and that this is the root cause of its continuing minority problems.

What is a Social Contract?

In general, one may say a social contract is an abstract exposition on the public law that forms the theory of a state. At their introduction into western civilization, the social contract ideas represented a constant refutation of Grotius and Pufendorf (the proponents of absolute monarchy), which were natural outcroppings of Christian theories of temporal power, formulated by men like Saint Paul, who asserted, unlike his counterparts in the Islamic world,[4] the divine origin of civil power. "All souls," says Saint Paul, "are submitted to the superior power because there is no power other than that which comes from God; he who rebels against civil power rebels against God's order." To resist the established government, according to Christianity, was to resist the will of God. This was a morality of submission to civil authority that became the traditional doctrine of the Church in face of political pressures. This doctrine was present in the western world from the time of the medieval disciplines of Saint Augustine to Bossuet.

It was precisely this unquestioning submission to political power that was repudiated by the social contract, although some of those who professed the absolutist orientation such as Grotius and Pufendorf, admitted that under certain circumstances, such as when a government became tyrannical and abusive or biased against a race, the right of resistance (*le droit de resistance*) was applicable. Among these thinkers, we also find the contractual theories of sovereignty which were initially evoked in western civilization by Mannegold de Lautenbach in the conflict during the Gregorian reform wherein Church and Empire were opposed, the theories of resistance to

tyranny elaborated by Protestant monarchists in the 16th century, and by Jurieu in the 17th century.

This question of the right to resist, denied by the doctrine of divine power, gives one a clear picture of the large gap between these former doctrines and theories, and the theories of the social contract. The advent of social contract theory represented a new age from that of the divine origin of government power -- a passage from submission to consensualism. Man, living originally free and equal in nature, without social connection, according to the social contract, could pass from the state of nature to the state of living in a society only by means of a social contract.

Jean-Jacques Rousseau, an author of the social contract in the 18th century, suggested like Plato and Aristotle that only in a legitimately established social state can man find his full growth, his *"raison d'etre"* and his perfection. Of course this orientation was the reverse of that of other social contract thinkers like Locke and Montesquieu, for whom the double aspect of social and individual man created a fundamental contradiction. For them, this fundamental ambivalence was a fatal tragedy which society could do nothing to heal, while Rousseau insisted that there could be a reconstitution between individual and social man by an appropriate organization, which reconciled the authority to all and freedom to each.

However, the writings of Rousseau, Hobbes and Locke had the same effect of exploding myths of rulership that protected corrupt and selfish regimes. In the place of these myths they provided a rational account of legitimacy that made each individual the judge of his own best interest and gave him the right to choose rulers who were bound to protect him. Hobbes and Locke gave the governed individual an equal right to selfishness. The ruled are not directed by nature to be ruled, any more than the rulers naturally care only for the good of the ruled. Ruler and ruled can consciously draw up a contract by which the separate interests of each are protected. But they are never one, sharing the same highest interest like the organs in the body. Viewing the nation as a network of families and loyalty to the state as resulting from self-interest and family love, Locke and Hobbes differed from Rousseau in emphasizing the importance of protecting private property in line with maintaining equality.

In the U.S., where Locke's concept of the protection of private property is so highly regarded among Anglo-Americans, communism or socialism never made much headway. Locke's definition of property suited, and still suits, the American historical economic

development, and Rousseau's critique of private property made almost no impression, although it made a very strong impression in Europe.[5] Was the availability for the taking of immense areas of land belonging to the Native American instrumental in making Rousseau's critique insignificant? This protection of the right to private property was not extended to include the Africans and Native Americans until after all the available land had been settled. Did the protection and ownership of private property appeal to the American historical needs because the enslaved Africans were considered private property? Is it fair to suggest that Plato's equality among equals was transformed to equal opportunity among equals to share in the unlimited exploitation of the land and labor of the minorities?

The writings of Locke, Rousseau and Hobbes were available to both the American and French revolution. However, these ideas were employed quite differently in accordance with the different politico-economic and social situations. They brought the important news that by nature all men are free and equal and that they have rights to life, liberty and the pursuit of property. But the American colonist, having accepted these ideas while at the same time enslaving the Africans and dispossessing the Native Americans, found themselves in a dilemma wherein they wished to continue these ideas, to identify with key ideals, but at the same time to continue to profit from the anti-ideal, which the Lockean belief in self-interest led them to believe in equally.

The result was the American "trick": the surrender of morality and higher aspirations to self-interest. Through their legal institutions, they projected the Africans and Native Americans as less than human. By this means, all human beings could be free and equal in America, and American history a history of freedom, human rights and social justice and -- not to be forgotten, equal opportunity. This solution to ignore the equal humanity of the minorities was no doubt a founding pillar of the anti-social contract. By ignoring the equal humanity of the minorities, America began the long process of denying the reality of its history. The Anglo-Americans were a people living under an enlightened social contract (the U.S. Constitution) according to which all human beings (of the majority ethny) were equal, and the Africans were private property..

The anti-social contract appears only when or if we accept or realize that one group of human beings was forced to enter into an association pact with another group of human beings in the position of their private property, as private property was defined and treated in their social contract.

Locke and Rousseau agreed on most basic ideas, which became the firm foundation of our modern state, and in the philosophy of neither great thinker was the American circumvention envisaged. The American solution of delineating the group to be exploited as less than human while the group to benefit was defined as the true human being, was no doubt so simple and silly as not to have likely occurred to them.

Where Locke and Rousseau fundamentally disagreed was on the role of the state and that of the individual, which still forms the foundation for the modern conflict between socialism and capitalism. The English and American ethnies founded their governments according to the Lockean interpretation of the role of the states, with the accent on the necessity for the state to protect private property. Rousseau inspired all later attempts in thought such as our own, to alter, correct, or escape from the Americanized Lockean concepts. It was the colonists' adherence to self-interest above morality that led to the American "trick". Rousseau disagreed with Locke that self-interest, however understood, is in any automatic harmony with what civil society needs and demands:

He who in the civil order wants to preserve the primacy of the sentiments of nature, does not know what he wants, always is in contradiction with himself; always floating between his inclination and his duties, he will never be either man or citizen. He will be good neither for himself nor for others. He will be one of these men of our days, a Frenchman, an Englishman, a bourgeois. He will be nothing. 6

Different from Rousseau, Locke and Hobbes suggest man's motor focus to be fear of death -- the negative experience of nature -- and they overlook the positive side of these forces. For Hobbes and Locke, nature is near and unattractive, and man's movement into society was all good. For Rousseau, nature is distant and attractive, and man's movement towards society was difficult and divided man. For Rousseau, the bourgeois is the price paid for the Hobbesian and Lockean orientation of detaching man from his higher morality or aspirations, making him less distinguishable from the other animals. The bourgeois is he who most of all cannot afford to look to his real self, who denies the evidence of the id in himself, who is most made over for the purpose of society which does not even promise him perfection or salvation, but merely buys him off.

Rousseau was wholly political, and saw deeds as central to the life of a people, and it is precisely the legitimate state, the very condi-

tion for the existence of a people, that Rousseau accuses his imme-
diate predecessors of having misunderstood or ignored. The ideas
of Rousseau *a propos* the social contract are idealistic and rational,
because they attempt to abstractly construct by simulation the model
of a legitimate state. His social contract idea is the discovery of a logi-
cian not an historian, of an ideologist not a sociologist.

And yet, the social contract notion, though not derived from
empirical, sociological verification, has, once it has come into exis-
tence, taken on a life of its own. Who could suggest that the
following ideas do not form the unstated rationale for the submission
to government in contemporary democracies -- that the government
of the people and by the people (in non multi-national states) is,
finally, as asserted by Rousseau, the government of all by all and of
each by each. That in such a government there is no contradiction
between authority and freedom, between each person and the
others. That the true destiny of man was to obtain this fraternal soci-
ety, and not oppression of man by man. That this could not be
established by a convention of "*superieur avec l'inferieur*" (an anti-
social contract), but by a convention of the whole with each.

While the influence of Lockean notions of the social contract may
have had a more direct impact on the formulation of the U.S. Consti-
tution, we have chosen to examine most rigorously the social
contract tenets formulated by Rousseau for our elaboration of the
legitimate and ideal social contract, and by extension, the contract
which should apply to multi-national states. This is because Rous-
seau's social contract is the most democratic or libertarian of all those
formulated by 18th century thinkers, and because indeed, his con-
ception of the social contract is most likely to be in harmony with the
profound implicit sentiments as to the nature of democracy in 20th
century thought.

But this does not preclude the fact, and we emphasize it again,
that all social contract theories were united in one tenet: that the
legitimacy of the governing power of a society is determined *by their
consent or agreement to allow that authority to govern them.* It is
here that we find important differences between the social contract
and the anti-social contract: The former has established legitimacy
through the consent of the governed; the latter, the anti-social
contract, has no moral legitimacy.

First we shall look at the ideal tenets of the social contract which
was formed between the European-Americans and their govern-

ment, and at the same time suggest what the same tenets would mean if applied to the national minorities. Then in Part II we shall present in greater detail the historical development of the anti-social contract, and elaborate some of its components.

{Note that when Rousseau speaks of the people as the governed or citizens, etc., we, for the purposes of highlighting the present day problems of multi-national states, often substitute the term ethnies, nationalities, minorities, etc.. We feel that this is valid not only because it follows the true logic of what Rousseau is saying, but also because we realize that Rousseau was thinking of the nation-state when he wrote. It would seem incorrect to argue that Rousseau felt that citizens in multi-national states did not share the same rights and duties.}

THE SOCIAL CONTRACT:
The Formation of the Multi-National State

Although today, Article 27 of the Human Rights Covenant of the United Nations calling for governments to officially recognize minorities and provide special measures for their equal-status relation with the majority serves as a basis for the social contract governments *should* institute between minorities and majorities in multinational states, we shall refer back to the philosophical sources in western civilization of the main written ideas about freedom and equality that found their way into treaties, state practices, etc., and eventually into Article 27 of the Covenant on Civil and Political Rights, one of the major elaborating human rights treaties of the Universal Declaration of Human Rights.

The chief notions of freedom, equality, the rights and duties of governments *a propos* their citizens during the grand period of developing national consciousness in Europe leading up to and after the French revolution can, as earlier suggested, be summarized from the work of Jean-Jaques Rousseau. Following is an analysis of passages from Rousseau, as we feel they would apply to minority-majority relations in multi-national states., then the passage from Rousseau from which this analysis was derived, and occasional comments.

1. *The politics of a state should represent the general will, but to be the general will, all elements (both minorities nationals and majority nationals) integrated into a state must participate in its formation.*

{La volonté général, c'est la volonté du corps politiques de l'état... la volonté générale, pour être vraiment elle... elle doit partir de tous pour s'appliquer à tous... tous les associes participent à la volition. 7

Comment: The U.S., in integrating the African and Native American into the state, did not permit them to vote, hold office, nor participate in any significant manner in the formation of the U.S. Constitution, etc. They were prevented from normal policy participation until such time as their vote would be meaningless as far as determining significant orientations of the U.S.A.. Furthermore, this implies that before a minority is integrated into a state, that minority should be given the opportunity to decide by national or internationally supervised referendum whether or not they want to be a part of that state, and if so, under what conditions they are willing to accept to be a part of that state. Such a vote was held for the Anglo-Texans and Anglo-Americans of other states prior to their entry into the union, but not for the Africans or Native Americans.

2. The reason for government is to assure that the general will (the will formed by the participation of all citizens, both minority and majority) is respected. The chief purpose of the constitution is to defend the public and individual freedoms even against the government itself.

{Le gouvernement, dira Robespierre, est institué pour fair respecter la volonté générale, mais les hommes qui gouvernent ont une volonté individuelle...le premier objet de toute Constitution doit être de défendre la liberté publique et individuelle contre le gouvernment lui-même.} 8

Comment: In relation to the Native and African-Americans, since they did not participate in the general politics, the government can not be said to have been founded to respect the general will of all associates. The Constitution during most of its life span has not been interpreted so as to defend their public and individual liberty. (We refer the reader to the legal summary of important court cases concerning the African-American minority during the period 1897-1960, on pp. 65 of this text.) As a matter of fact, when first created, the Constitution at minimum ignored slavery, and although economic and political circumstances eventually led to an interpretation of the Constitution as being against slavery,[9] it left intact until 1960, a short twenty years ago, a jungle of Jim Crow laws designed principally to limit or negate the freedom allotted.

3. In relation to equality in integrating, it is not necessary that the minority be on the same economic level as the majority, but that the

government should act in such a manner as to make certain that the economic gap between the majority and minority is not so great as to make future equal status and equal opportunity impossible, or to place the minority under circumstances wherein they feel obliged to sell themselves to the interest of the majority in order to survive.

{A l'égard de l'égalité, il ne faut pas entendre par ce mot que les degrés de puissance et de richesse soient absolument les mêmes; mais que... nul citoyen ne soit assez opulent pour pouvoir en acheter un autre, et nul assez pauvre pour être contraint de se vendre.}[10]

Comment: In the U.S., it is obvious and freely admitted that national minorities, particularly the African and Native Americans, own so little of the country's wealth and richness that they are almost totally dependent on the Anglo-Americans for their day-to-day survival, education, etc.. It is also equally clear that this total dependence was forced on them by conquest and slavery. The present U.S. government is still unable to initiate mandatory affirmative action and quota programs.

4. The maintenance of social order is most important, and is the foundation upon which the other human rights are realized. However, public order should result from an appropriate social contract and its implementation.

{Mais l'order social est un droit sacré qui sert de base à tous les autres. Cependent, ce droit ne vient point de la nature; il est donc fondé sur des conventions}[11]

Comment: Often where no provision is made for minority rights or minority equal status, the popularity of the ideal of law and order is quickly seized upon by governments to justify violent repression of minority nationalities instead of creation of majority-minority agreements which will serve as the basis for moral enforcement of a mutually advantageous order.

5. The most powerful of majority nationalities is never strong enough to always be the master unless it transforms its will into law and makes obedience to this law the duty of each individual and ethny in the State. However, the duty to obey the law exists only when the law is just. If the minority is obliged to obey laws by force , they no longer need feel a duty to obey them and in this way, only force obliges the minority to obey the law. If the use of force is no longer possible, and special measures to create equal status are not implemented, then the minority has no obligation to obey.

{Le plus fort n'est jamais assez fort pour etre toujours le maitre, s'il ne transforme sa force en droit, et l'obeissance en devoir. S'il faut obeir par force, on n'a pas besoin d'obeir par devoir, et si l'on n'est plus force d'obeir, on n'y est plus oblige.}12

Comment: It is obvious that application of Anglo-American law to the enslaved Africans was instituted and maintained by force, suppression and coercion. As the Anglo-American power structure found its power to apply force limited, the more the members of national minorities dared to defy the laws. Probably the disproportionately higher crime rates among the national minorities are a testimony to the need for law to carry justice in order to have morality and for members of the oppressed minorities to see it as their duty to follow the law. It is improbable that many of the minority members in the U.S. feel that it is their duty as citizens to obey the law. Instead, they most likely feel that they must obey the law in order not to be punished by force. (While this is only a speculative proposition, it is a proposition that can be empirically tested.)

6. *No morality can result from coercing or forcing a minority into following the law. Force or coercion is a physical power, and for a minority to submit to force is an act of necessity, not an act of will. Above all, it is an act of prudence, and thus can never be considered as a duty. Thus force cannot make law, and one is only obliged to obey moral and legitimate law.*

{La force est une puissance physique; je ne vois point quelle moralité peut résulter de ses effets. Cédez à la force est un act de nécessité, non de volonté; c'est tout au plus un acte de prudence. En quel sense pourrace être un devoir?... Convenons donc que force ne fait pas droit, et qu'on n'est obligé d'obéir qu'aux puissances légitimes.}13

7. *There is no natural authority of one nationality over another, and since force cannot produce law, it is only formal or informal agreement (social contract) between ethnies that remains the legitimate common basis for authority in a multinational state.*

{Puisque aucun homme n'a une autorité naturelle sur son semblable, et puisque la force ne produit aucun droit, restent donc les conventions pour base de toute autorité légitime parmi les hommes.} 14

8. *It can be said that the government does not provide for the human rights of minorities because to do so may break the domestic purse and disrupt law and order. But what good is this domestic peace or 'enforced order' to the minority living in a state of gross inequality and*

injury. *What advantage is it, if this law, order and peace itself is based on minority nationalities agreeing to be contented with poverty and oppression? If this peace is in fact one of their miseries? One can have law and order while living in a jail. The Greeks, while enclosed in the cage of the Cyclops, lived in peace while waiting to be eaten.*

{On dira que le depote assure a ses sujets le tranquillité civile.. Ou' y gagnent-ils, a cette tranquillité même est une de leurs miseres? On vit tranquille aussi dans les cachets. Les grecs enfermeés dans l'antre du cyclope y vivoient tranquilles, en attendent que leur tour vint d'être dévores.} 15

9. *To say that a minority has voluntarily submitted itself to gross inequality and oppression is absurd; such an act would be illegitimate and null because it is illogical and does not meet the test of common sense. To say that a whole people have voluntarily done so is to say that they are crazy, and craziness does not make law or moral right. To renounce one's right to freedom and duties is to renounce one's right to be human. Such a renunciation is incompatible with human nature.*

{Dire qu'un homme se donne gratuitement, c'est dire une chose absurde et inconcivable; un tel acte est illégitime et nul, par cela seul que celui qui le fait n'est pas dans son bon sens. Dire le même chose de tout un peuple, c'est supposer un peupe de fous; la folie ne fait pas droit... Renoncer à sa liberté, c'est renoncer à sa qualité d'homme, aux droits de l'humanité, même à ses devoirs. Il n'y a nul dédommagement possible pour quiconque renonce à tout. Une telle renonciation est incompatible avec la nature de l'homme.} 16

10. *Some like Grotius suggest that the right to enslave or oppress other nationalities derives from the rights of conquest. The defeated minority can trade its freedom for its lives. Say the African nations, having been defeated, agreed to the fair deal of accepting enslavement in order to save their lives, or as many Americans understand, the conquered and enslaved Africans accepted economic and social exploitation, ethnic and cultural genocide in order to be released from slavery. However, it is clear that this assumed right to enslave or oppress deriving from the right of conquest and the proposed right to kill the conquered does not hold water. Primitive men living in a state of nature did not initiate a relationship (rapport) sufficiently constant to represent either peace or war. They were not naturally enemies. War does not derive simply from personal relations. It is the relations of natural things, not of men, that constitute war... War is*

thus never a relation between men, but between states, in which the individuals are only accidentally enemies, and not as men nor even as citizens. but as soldiers. At the end of the war, one does not have the right to kill the citizens of the conquered state unless they are armed and resisting. But as soon as one lays down his arms, he ceases to be an enemy or instrument of the enemy and becomes again, simply a man.

At this point, the conqueror no longer has a right on his life. Thus, one does not have the right to kill one's enemy if he refuses slavery, or to keep him in slavery if he refuses oppression and inequality. The right to enslave (even at the time of the founding of the U.S.) is null, void, not only because it is illegal, but because it is absurd... The words slave and right (law) are contradictory and mutually exclusive.

{Grotius et les autres tirent de la guerre une autre origine du prétendu droit d'esclavage. Le vainqueur ayant, selon eux, le droit de tuer le vaincu, celui-ci peut racheter sa vie aux dépens de sa liberté... Mais il est clair que ce prétendu droit de tuer les vaincus ne résulte en aucune manière de l'état de guerre. Par cela seul, que les hommes, vivent dans leur primitive indé-pendence, n'ont point entre eux de rapport assez constant pour constituer ni l'état de paix ni l'état de guerre, ils ne sont point naturallement enemis. C'est le rapport des choses et non des hommes qui constitue la guerre, et l'état de guerre ne pouvant nâtre des simples relations personnelles, mais seulement des relations réelles.... La guerre n'est donc point une relation d'homme à homme, mais une relation d'État à Etat, dans laquelle les particu-liers ne sont enemis qu' accidentellement, non point comme hommes, ni même comme citoyens mais comme soldats. La fin de la guerre étant la destruction de l'état enemi, on a droit d'en tuer les défenseurs tant qu'ils ont les armes à la main; mais sitôt qu'ils les posent et se rendent, cessant d'être ennemis ou instruments de l'ennemi, ils redeviennent simplement hommes, et l'on n'a plus de droit sur leur vie...On n'a le droit de tuer l'ennemi que quand on ne peut le faire esclave; le droit de le faire esclave ne vient donc pas du droit de le tuer; c'est donc un échange inique de lui faire ach-eter au prix de sa liberté, sa vie, sur laquelle on n'a aucun droit.... Ainsi de quelque sens qu'on envisage les choses, le droit d'esclavage est nul, non seulement parce qu'il est illégitime, mais parce qu'il est absurde, et ne signi-fie rien. Ces mots, *esclave* et *droit*, sont contradictoires; ils s'excluent mutuellement.} 17

*11. In a multinational state, the social contract unifies all nationalities, minorities and majority, into one political unit or entity in which each ethnicity gives its all under conditions of equal status, and **wherein the particular interest of each ethnicity is flushed of all***

contents that would cause oppression to the others. The rulers of this political unit (the state) derive their authority from the sanctity of the social contract and can never separate their authority from this contract. In such a unit or state, one cannot attack the state without all minorities and majority ethnies desiring to come together for its protection, as provided for in the contract. However, within this unit, each nationality can have its own customs, institutions and political apparatus which can be contradictory or dissimilar to the general will which it holds as citizens of the state. However, these dissimilar interests serve to enlarge and contribute to the common interest and the general will.

{Le (contrat social) se reduisent toutes à une seule: savoir, l'aliénation totale de chaque associé avec tous ses droits à toute la communauté... car premièrement, chaque se donnant tout entier, la condition est égale pour tous.. nul n'a intérêt de la rendre onéreuse aux autres... Mais le corps politique ou le souverain ne tirent son être que de la sainteté du contrat, ne peut jamais s'obliger, même envers autrui, à rien qui dérogé à cet acte primitif, comme d'aliéner quelque portion de lui-meme, ou de se soumettre à un autre souverain. Violer l'acte par lequel il exist, seroit s'anéantir... Sitôt que cette multitude est ainsi réunie en un corps, on ne peut offenser un des membres sans attaquer le corps... En effet, chaque individu peut, comme homme, avoir une volonté particulière contraire au dissemblable à la volonté générale qu'il a comme citoyen.... son existence absolue, et naturellement indépendente, peut lui fair envisager ce qu'il doit à la cause commune comme un contribution gratuite.} 18

12. *The social contract is a very necessary element in the formation of multinational states because it reaffirms the engagement or duty of each ethny, race or nationality and thus provides the basis for the constraint by the state of any individual or group if they refuse to obey the general will (the laws of the state) under conditions of a social contract. This contract means nothing more than that one will be forced to be free because the maintenance of his right is the only way that the civil rights and duties of all citizens can be preserved.*

{Afin donc que ce pacte social ne soit pas un vain formulaire, il renferme tacitement cet engagement, qui seul peut donner de la force aux autres, que quiconque refusera d'obeir à la volonté générale, y sera contraint par tout le corps; ce qui ne signifie autre chose sinon qu'on le forcera à être libre; car telle est la condition qui donne chaque citoyen à la patrie le garantit de toute dépendance personnelle, condition qui fait l'artifice et le jeu de la machine politique, et qui seule rend légitimes les engagements civils.} 19

13. What does a nationality lose by associating itself with another nationality in forming a multinational state? Of course, it loses its right to act as absolutely independent of the other nationality. But it gains the economic, social and political advantages of being a part of a larger and more diverse political unit. Thus the essential element for encouraging nationalities to associate or unite is the nature of the social contract, ie. if the conditions of the agreement to associate are beneficial to all concerned and will benefit them. However, when the agreement favors one in particular, or is forced on one partner, a struggle for national political independence occurs, which out of necessity serves to weaken both. [20]

Eighteenth century ideas concerning settlers' rights and occupation as represented in Rousseau's Social Contract *state that in order to claim the rights of the first occupant, the territory to be occupied must be uninhabited, etc.. Obviously the Europeans who settled in America, South Africa , Algeria, etc. chose to ignore these ideals and opted instead for an older justification, the blind spot of the Christian Church of that period (which we will discuss in the next chapter.) It was the Church that provided the moral justification for their occupation, ignoring the fact that the lands involved were already occupied.*

{En général pour autoriser sur un terrain quelconque le droit de premier occupant, il faut les conditions suivants: premièrement, que ce terrain ne soit encore habité, etc. }[21]

15. The most important consequence of the social contract is that the general will alone directs the forces of the states towards the common welfare. Of course, in each multinational state, the dissimilarity of interest between nationalities produces opposition to particular policies desired by any one nationality. The resolution of these problems brings into existence certain institutions which create many points of common interest. These common interests of all nationalities are what make the society or multinational state possible. If there are not enough interests in common, then that multinational society cannot and should not exist, because it is uniquely upon common interest that a multinational society can be governed.

{La première et la plus importante conséquence des principes ci-devant établis est que la volonté générale peut seule diriger les forces de l'Etat selon la fin de son institution, qui est le bien commun; car, si l'opposition des interêts particuliers a rendu necessaire l'établissement des

sociétés, c'est l'accord de ces membres intérêts qui l'a rendu possible. C'est ce qu'il y a de commun dans ces différents intérêts qui forme le lien social.} 22

16. *It is for the same reason as mentioned above, that sovereignty is inalienable, that sovereignty becomes indivisible: because the will that governs is common to all nationalities. In such case, the will is an act of sovereignty and makes law; however, if what is called the general will represents only that of a majority ethnic group, it is an inadequate act, a proclamation, nothing more.*

{Par la même raison que la souveraineté est inaliénable, elle est indivisible; car la volonté est générale, ou elle ne l'est pas; elle est celle du corps du peuple, ou seulement d'une partie. Dans le premier cas, cette volonté déclarée est un acte de souveraineté et fait loi; dans le second, ce n'est qu'une volonté particulière, ou un act de magistrature; c'est un décret tout au plus.} 23

17. *When the association of nationalities into a state becomes such or is founded as such that one nationality, say the Anglo-Americans in the U.S., dominate all the rest, the state is no longer composed of the sum of many differences, but a unique difference in that there is no longer a general will because the will that dominates is the idea of one nationality dominating the will of all the others.*

{Enfin quand une de ces associations est si grande qu'elle l'emporte sur toutes les autres, vous n'avez plus pour résultat une somme de petites différences, mais un différence unique; alors il n'y a plus de volonté générale, et l'avis qui l'emporte n'est qu'un avis particulier.} 24

18. *The type of responsibilities and expectation (law) that were said to unite the African to other Americans, Africans to European South Africans, Native Americans to other Americans, etc. and into one nation, do not make obligations because only when such engagements and responsibilities are mutual do you have obligations and duties in an internationally legal and moral society. This is different from the work of the African slave or freeman working only to build Anglo-American culture. In an internationally legal and moral multinational state, in fulfilling one's obligations to the state and to the other nationalities, one also works for one's own self or national identity. Or conversely, in working for one's self or national identity, one also fulfills one's obligations to the state and to the other nationalities.*

{Les engagements qui nous lient au corps social ne sont obligatoire que parce qu'ils sont mutuels; et leur nature est telle qu'en les remplissant on ne peut travailler pour autrui sans travailler aussi pour soi.} 25

19. *The proclamation of an act of national sovereignty of a multinational state, such as the U.S. Declaration of Independence, should not have permitted a declaration of a convention between a superior and an inferior (an anti-social contract), but a convention between the government with each nationality or member. Such would be a legitimate convention because it is founded on a social contract; equitable because it expresses a will common to all; useful because it has only one objective and that is the common welfare; and solid because it unites behind it both the public force (that of all nationalities) as well as the government power. Note that in the Foreword, we suggest that the U.S. Constitution and Declaration of Independence were indeed social contracts insofar as they spoke exclusively to Anglo-Americans.*

{Qu' est-ce donc proprement qu'un acte de souveraineté? Ce n'est pas une convention du supérieur avec l'inférieur, mais une convention du corps avec chacun de ses membres: convention légitime, parce qu' elle a pour base le contrat social; équitable, parce qu'elle est commune à tous; utile parce qu'elle ne peut avoir d'autre objet que le bien général; et solide, parce qu'elle a pour garant la force publique et le pouvoir suprème.} [26]

20. *The ultimate objective of the social contract is to preserve state unity because each nationality, by seeking its own interest in the common interest, will also desire the means (state unity) that obtains their interest. And since the objective is inseparable from some compromise and risk of loss, each nationality accepts a certain degree of loss or risk for the common interest. One who conserves his life and well-being at the expense of others will also be willing to give it for the others if necessary.*

{Le traité social a pour fin la conservation des contractants. Qui veut la fin veut aussi les moyens, et ces moyens sont inséparable de quelques risques, même de quelques pertes. Qui veut conserver sa vie aux depens des autres doit la donner aussi pour eux quand il faut.} [27]

21. *1n a morally constituted multinational state, any individual or group that attacks the social contract becomes a rebel and traitor to all. Since the maintenance of the state is incompatible with such actions, the state has the moral right to punish the individual or groups. (However, where nationalities have been forcibly integrated into the state without a social contract, the logic of Rousseau's idea would suggest that they have every right to attack the existing anti-social contract for the purpose of establishing a social contract or to seek political independence.)*

{D'ailleurs, tout malfaiteur attaquant le droit social devient par ses for-
faits rebelle et traître à la patrie... Alors la conservation de l'Etat est
incompatible avec la sienne...} 28

*22. All justice comes from God, but if we knew how to receive it
directly from above, we would need neither law nor government...
Therefore we need social contracts, conventions and law to unite
the law to our duties and to deliver duties to each individual and each
nationality. In Islamically constituted multinational states, the Shariah
is instituted for this purpose, whereas Christians use secular law.*

{Toute justice vient de Dieu, lui seul en est la source; mais si nous
savions la reçevoir de si haut, nous n'aurions besoin ni de gouvernement ni
de lois... il faut donc des conventions et des lois pour unir les droits aux
devoirs et ramener la justice à son objet.}29

*23. Unlike the U.S. laws that decided that the African-American
would be the non-voting class or the out-class or the underclass, in a
morally constituted multinational state with a social contract as its
base, the law may establish several classes of citizens but it cannot
assign any particular nationality to any particular class.*

{...la loi peut faire plusieurs classes de citoyens, assigner même les
qualités qui donnerent droit à ces classes, mais elle ne peut nommer tel et
tels pour y être admis.} 30

*24. Politics and religion (Christianity) do not have a common objec-
tive. In the history of nations one always served as the instrument of
the other.* 31

{Il ne faut pas, de tout ceci, conclure avec Warburton que la politique
et la religion aient parmis nous un objet commun, mais que, dans l'origine
des nations, l'une sert d'instrument 'à l'autre.}32

*25. Once anti-social customs are established and rooted in a multi-
national state, reform becomes a vain and dangerous enterprise. The
ruling and dominant nationality, like a sick patient who is afraid to see
a doctor, cannot stand to see someone touch their wound.*

{Quand une fois, la coutumes sont établies et les prejugés enracinés,
c'est une entreprise dangereuse et vaine de vouloir les réformer.; le peuple
ne peut pas même souffrir qu'on touche a ses maux pour les détruire, sem-
blable à ces malades stupides et sans courage qui frémissent à l'aspect du
médecin.} 33

*26. The constitution of a multinational state is most strong and
durable when the conventions are observed to the point wherein the*

natural law and positive law always fall in concert on the same points.
{Ce qui rend la constitution d'un Etat véritablement solide et durable,
c'est quand les convenances sont tellement observées, que les rapports
naturels et les lois tombent toujours de concert sur les mêmes points...} 34

27. *As in the multinational state of Switzerland, any law which is not
ratified by each nationality (the people, in sum), is null and in point of
fact, not a law.*
{Toute loi que le peuple en personne n'a pas ratifiée est nulle; ce n'est
point une lois. Le peuple anglois pense être libre, il se trompe fort: il ne l'est
que durant l'élection des membres du parlement; sitôt qu'ils sont élus, il est
esclave.} 35

28. *In a morally constituted multinational state, the God of one nation-
ality or people has no rights over the other nationalities or peoples.*
{Le dieu d'un peuple n'avait aucun droit sur les autres peuples.} 36

During years of building the ideal of the nation-state in Europe,
the social contract as viewed by John Locke, Thomas Hobbes and
particularly Jean-Jacques Rousseau served as the idealized model
upon which the basis for association between peoples, and the
people as a whole with their government, was patterned. This is true,
although there were many differences between the views of Locke,
Hobbes and Rousseau. But, as mentioned in the introduction, the
relevant basics were the same. Nor are we suggesting that the only
reason for such associations were actually resulting from the ideals of
the social contract, nor that these ideals themselves were or should
have been the only basis for association and the formation of states.
In this book, we suggest that the general idea of some form of social
contract, be it contracts based more on Hobbes than on Locke or
Rousseau, served as the moral basis to justify the powers or
government's right to enforce its will, its designs, its values, its priori-
ties, its culture, etc., and demand obedience.

This social contract concept thus served as the moral and logical
basis for the promulgation of positive law and legal principles which
each citizen of the state was expected to uphold. With the advent of
the recognition of the existence of multinational states, we feel that
liberal democratic statesmen have attempted to apply the same ideal
without giving sufficient attention to the conscious multi-national
nature of such states. We hope that this book will assist in
encouraging a re-examination.

Although the men who concerned themselves most with the articulated formulation of the social contract were no doubt reacting against the pre-existing Christian concept of Divine Rule (particularly Rousseau and Locke), they were also influenced by it. But most importantly, the American, South African and Algerian settlers, when they were unable to find a moral tool in the social contract for claiming lands which they knew were first settled by others, turned back to the older, Christian religious doctrine. To understand this aspect of the advent of the anti-social contract, then, it is important to view the attitude of the Christian Church as interpreted in the U.S. as this attitude relates to the status of U.S. minorities. It will increase our understanding of how the U.S. Christian attitude was open to such usage by contrasting it with the attitude towards minorities that had developed in what is often called the world's second largest religion, Islam.

A Non-European Model

Just as Locke, Rousseau and Hobbes' model of the social contract ideals, with their Greek and Roman roots, were no doubt most influential in conditioning the political ideals that were instrumental in the formation of the U.S. social and anti-social contract (particularly the ancient Greek fuller or lesser humanity concept as expressed by Plato's ideal in *The Republic* of Communist relations among equals and master/servant relations among unequals), there are other historical models, albeit non-western models, for the social contract which manifest moral consciousness of the need for equal status minority/majority relations. As an example, we turn to the Islamic model, occurring hundreds of years before the American experiment Minorities in the earlier Islamic states were not, according to Islamic law, to be deprived of protection of life, property or freedom of religion. They (*ahl al-dhimma* or *dhimmis*) were, on the other hand, accorded membership in the Islamic state under a social contract. They were called *al-mu'ahadun*, which means contractees or holders of the covenant, because they were granted membership in the state through contracts concluded between them or their ancestors and the Islamic state (muslim majority).

The Quran and the Sunna or the practices of the Prophet Muhammad (PBUH) are the two authorities on which the rights and duties of non-Muslims living in a Muslim state were decided. Following are some quotes from the Qur'an:

And if you give word {to a minority or non-Muslim ethny}, do justice thereunto, even though it be against a kinsman; and fulfil the covenant of God: This He commandeth you so that you may remember. 6:152.

So long as they (Non-Muslims or minorities) are true to you, be true to them. 9:7

Allah does not forbid you respecting those who have not made war against you on account of (your) religion, and have not driven you forth from your homes, that you show them kindness and deal with them justly; surely, Allah loves the doers of justice. 60:837

Legal justice in the Islamic state did not end with civil right. It also recognized their right to be different and providing them with what they need for equal status with the Muslim majority.

The Prophet (PBUH) of Islam is reported to have said:

Beware whoseoever is cruel and hard on a contractee or curtails his rights or burdens him more than he can endure or takes anythling of his property against his free will, I shall myself be a plaintiff against him on the day of Judgement.38

Here it is interesting to note that Islam refers not only to curtailment of rights (human and civil -- since rights are defined by the Quran, Sunna and Shariah, there is no difference between human and civil rights in Islam) but also of "cruel", "hard" and "burdens", which words seem to indicate that the contractees must be afforded special consideration and the right to be different with equal status. These notions are still alien to English and American law, but are found in the international legal concept of special measures.

The Prophet (PBUH) of Islam is also reported as having said:

And once they (Minorities) are willing to conclude the *dhimma* contract then let it be clearly known to them that all rights and duties are equal and reciprocal between you and them.39

One of the first Islamic treaties was concluded between the Muslims and the Jews of Madina whereby a kind of multi-national state was established which embraced those who believed in the Prophet and those who were willing to accept his authority as a political head. It was a form of confederacy, the forerunner of today's multi-national state. In the constitutional document drawn up the rights of each national minority were safeguarded. The attitude of the Muslim rulers towards the non-Muslims of Madina is evident from the following extracts from this document:

All Jews who choose to join us shall have all the protection that Muslims have. Neither will they be oppressed nor shall there be any Muslim communal agitation against them. To the Jews their religion and to the Muslims their religion.[40]

It was also provided in this document that "responsibility for any act of oppression or wickedness shall always be personal: Between all there would be justice and benevolence as well as mutual counsel and advice. There was provision for joint responsibility for defence against every attack on Madina and against any aggression directed against any of those who adhere to the written social contract. The expenditure of war will be shared by Jews with Muslims as long as the fighting lasts. Those who choose to leave can leave in safety and those who choose to settle in Madina can settle in safety, except if held responsible for injustice or transgression."[41]

In summary, this social contract document contained the following:

i. The institution of a socio-political state embracing the minority Jews and Muslim majority;

ii. Equality of protection and security for all, irrespective of religious or ethnic differences;

iii. Every one was held responsible for his personal acts and no one was burdened for the deeds of others;

iv. The defence of this confederal state was to be the duty of all elements of the population, including the Jews.

The non-Muslim minority population of the State had a say in the execution of government.

Another minority treaty which followed the treaty with the Jewish minority of Madina was the famous treaty with the Christians of Najran.[42] According to this agreement, "the security of God and the pledge of the Prophet (PBUH)" were extended to the people of Najran and its dependencies. This protection applied equally to their property, life and religion, to the absent and the present, kith and kin, churches, and all that they possessed, big or small.

No bishop in his area was to be removed (by Muslims), nor a monk from his monastery. They were also not to be humiliated.[43]

This treaty between the Muslims and the Christians of Najran was an example for all the later Caliphs. Thus after the subjugation of Gira, and as soon as the people had taken an oath of allegiance, Khalid-ibn-Walid issued a proclamation by which he guaranteed the life, liberty and property of the inhabitants and wrote to Umar ibn

Khattab, the then Caliph, that: "They shall not be prevented from beating their naqus and taking out their crosses on occasions of festivals." And this declaration, says Abu Yusuf, "was approved and sanctioned by the Caliph."[44]

Non-Muslim minorities were exempted from conscription. They were citizens of the State, and had the right to be protected and defended. For this protection they paid jizya..[50] It was in the life time of Muhammad (PBUH) that the jizya (a protection tax) was accepted from the Jews, the Christians, the Sabians, and the Zoroastrians. Hindus and Buddhists were also taken into dhimma when Sind fell to the Muslims in 712 A.D.[45] Some Muslim jurists held that jizya could be accepted only from the People of the Book but in practice all non-Muslims were treated as such and jizya was also accepted from Hindus and Buddhists.

The non-Muslims minorities of an Islamic State enjoyed, in many respects, better facilities than the Muslim subjects. They (minorities) were exempted from the surplus property tax, i.e. zakat [46] which all Muslims, male or female, young or old, pay annually at the rate of two and a half per cent on their cash, commercial goods, herds of cattle etc.

Military service was not compulsory for non-Muslims, whereas all Muslims were subject to it.[47] Islamic law allows minorities to take their cases to the courts presided over by their co-religionists for judgment in accordance with their own laws.[48] Each minority had its own court and judicial system.

Minorities were required to pay the jizya annually amounting to from 12 to 46 dirhams per person. The rich were required to pay 48 dirhams, those with average means 24, those practicing handicrafts for a living like the peasants 12 only (a form of progressive income tax.)

Jizya was imposed only on males; women and children were exempted. Instead of cash, jizya could be paid in kind. It was not levied on the indigent who received charity, nor from the blind who had no profession and did not work, nor from the chronically sick or the crippled (except those who were rich), nor from the monks or the very old who could not work and had no wealth. Minority women, children and indigent, were not only exempted from jizya, they were helped by stipends from the Bayt al-Mal (public treasury), [49] when necessary.

Minorities were also entitled to keep conquered lands in their

possession. After the subjugation of Iraq, Umar ibn al-Khattab, the second caliph, summoned his advisers who were mostly companions of Muhammad (PBUH), and it was settled, after long discussion and argument, that all the conquered lands should be left in the hands of the owners on the payment of *Kharaj.* 51 Also when polytheistic minorities were allowed to live among Muslims in toleration of their disbelief in only one God, their other "sins" were considered minor in comparison.[52]

In short, the non-Muslim minorities were allowed to continue those practices proper to their ethnicity or religion, and were not forced to assimilate into the dominant majority, ie. become Muslims. As *dhimma,* they entered into membership in the state on a contractual basis; their existence as a nation or ethny, was legally recognized by the state.

The state did not provide financial support for non-Muslim cultural traditions, but neither did it require taxes *(zakat)* from these communities although it was required from the Muslim majority. These communities were left to levy their own taxes for the benefit of their own community.

In essence, minority communities continued to function as nations, conducting normal business with each other and with the majority (except for the practice of usury. Also "foreign relations" insofar as it concerned politics and military protection remained the province of the Muslim majority.)[53]

Although there is little research linking the modern ideal of minority protection in international law to the Islamic influence, similarities between the two, as well as studies of the religious treaty basis of customary international law, strongly suggests that these earlier Islamic state practices had a significant influence on the introduction of minority rights into the European international legal system.

Constitutions In Multi-National States:
A Contemporary View

The world today is divided into slightly less than 200 independent sovereign states, many of which are multi-national. They are territorially defined and endowed with exclusive jurisdiction over all persons residing within them (save diplomats and those bearing special privileges and immunities). The governments of the great majority of states are supposed to be determined according to constitutions of their independent choosing, documents that

generally reflect their particular values and political orientation, constitutions which are thought to contain a complete social contract. These constitutions are also supposed to enumerate popular safeguards that theoretically protect minorities from the arbitrary uses of power by the majority ethny or party in power.

Such ideal constitutions can be said to represent their complete social contracts and can be characterized as agreements between people and their governors that protect the former from the latter by providing the legal basis whereby the governors and governed become subject to the same rule of law. While such constitutions do not necessarily confer power upon authority, they are supposed to limit the power which authority already possesses, and in supporting this ideal, they do serve to give that power a sense of legitimacy. Their protection is thought to be available to the individual citizen and minority, to allow for an extraordinary range of nonconformity and right to be different, while encouraging originality, creativity and dynamic self-expression.

Such constitutions should give significance to diversity and the plural nature of the multi-national state. Such constitutions should address the necessity of coexistence in equal status of peoples with different physical characteristics, distinctive cultures, ethnic and historical backgrounds, and religious persuasions. Such constitutions should acknowledge the polyglot nature of multi-national states, the lack of homogeneity, and the need to tolerate differences in an expanding community. They should foster in their operation the notion of integration, and in promoting national unity they should acknowledge the importance of equilibrium between competitive nationalities.

However, not all modern constitutions of multi-national states contain the complete societal social contract. Often hidden or unwritten in the constitution is a part of the social contract which serves to unite the majority nationality of the multi-national state around an informal agreement to exploit, dominate and/or maintain privileges in relation to the minority nationalities of the same state. To see the complete social contract in such cases, "peering behind the constitution" becomes essential. The student of this type of constitutions learns little about the nature of the social contract by simply reading legal documents. The working of government, the course of politics, the nature and function of decision-making can only be ascertained from the observation of actual power relations objectified in the on-going legislative decisions, both legal and no longer legal.

The nerves of government, the sinews of society, the interaction between public and officialdom, between minority nationalities and majority, etc., can only be understood by analytical legal research and above all, by rational analysis.

Comparative governmental and constitutional investigation is also useful for accurate evaluation. Nothing can be studied in a vacuum, and it is only by comparing the operations of different state constitutional systems, juxtaposing the ideal with the real, that we come to truly understand our own. With such mind-set, with empiricism as a frame of reference, it becomes possible to weigh, measure, or gauge the degree to which a constitution in a multi-national state represents its complete social contract.

In the ideal concept of democracy, governments are established for and serve the interest of the people, while governors are chosen by and made responsible to their citizens. Thus, constitutions are supposed to transform this theory into practice, and therefore in multi-national states, the degree of protection (as viewed through its legal history) accorded the weakest minority is a cardinal test of whether the constitution contains the complete social contract.[54] Even a cursory glance at the historically consistent master/slave -- boss/servant relationship between majority and minority suggested in U.S. legal history gives us cause for doubting whether the noble words of the U.S. Constitution represent its complete social contract.

THE AMERICAN CONSTITUTION:
THE SOCIAL AND ANTI-SOCIAL CONTRACT

As before mentioned, at the time of the writing of the U.S. Constitution, African-Americans were enslaved, and Native Americans in the east had been dispossessed of their lands, with their brothers in the west shortly to meet a similar fate. The formal social contract that formed the American government -- the U.S. Constitution -- also brought into existence an informal anti-social contract that determined the nature of the relationship between the Anglo-American majority and its national minorities. By the act of writing a fully democratic constitution for all human beings at the same time that the condition of the national minorities was ignored, and left in a position of absolute slavery and inequality, the first official U.S. act of humanizing and de-humanizing occurred simultaneously. The complete omission of the U.S. national minorities (the African and Native Americans) from any participation in the formation of the U.S. Constitution, while extending the principles of the Constitution to

govern all people in the U.S. including the national minorities, was the original American sleight of hand that served as the unwritten model of how the informal and unspoken anti-social contract would function *vis-à-vis* the national minorities well into the present day. The unwritten rule of the anti-social contract is that input from the minorities is to be ignored unless it agrees with and benefits the majority.

The national minorities were to be compelled to follow the laws and principles completely determined by the Anglo-American majority regardless of the fact that they had no positive significant input into the formation of such laws and principles, and regardless of whatever uneven and negative effect such laws and principles might have on them. If the great Fathers of the American Constitution could claim to own members of the national minorities at the same time as they formulated the ideal principles of freedom for the Constitution under which they would be governed, certainly later generations saw no contradiction in upholding the highest ideals of human rights around the world, while not extending even many elementary rights to their national minorities. In short, the U.S. Constitution established two contracts, one a formal social contract with American subjects of European descent, and the second an informal unspoken anti-social contract between these European Americans which concerned how minorities would be treated.[55]

The anti-social contract is an unwritten, unspoken and unofficial agreement between the U.S. ruling elites and the remainder of the white ethny to maintain the minorities, particularly the African and Native American minorities, in a position inferior to that of the white ethny. The anti-social contract guaranteed to this newly formed ethny a plentiful supply of slave and later cheap labor, a defenseless mass of consumers for its products and services, and vast tracts of depopulated lands for its economic and socio-cultural exploitation. For this opportunity and privilege, the various European races in the U.S., the Germans, Irish, English, and later the Italians, Poles, Czechs, etc., agreed to accept the Anglo-Saxonizing "melting pot" and become, simply, Anglo-American.

Also, ignoring the existence of the Africans' enslavement in the constitution signalled the acceptability of certain popular notions that had already taken root: that the culture, values, history, needs, and input, etc. of the Native and African American were worthless, and need not be given consideration in defining the U.S. identity, its history, its values, etc., and by logical implication, that the Anglo-

American rulers should always maintain a disproportionate degree of U.S. power in order to guarantee that the value and history of the Anglo-Americans will continue to dominate in all areas. Of course, the foundation of a homogeneous white Anglo-Saxonized nation had been an implicit and explicit goal of the ruling Anglo-Saxon elite from the first colonization of America regardless of the reality of the existence of the enslaved Africans and dispossessed Native Americans, and its ramifications spread throughout the history of the country and carry on to this day. Is it not true that even today we celebrate the "discovery" of America by Columbus? Today, do we say that Africans were among the founding fathers of the U.S. ? We can easily see how these above mentioned anti-historical and anti-social notions will lead to the elaboration of legislation, attidues and education, etc. that produces the U.S. anti-social contract's most potent components: white nationalism and its catalytic implementing agent, American racism.

PART TWO:

WHITE NATIONALISM

The early history of America witnessed a European fanaticism so profound that it permitted the brutal enslavement of millions of Africans and the dispossession and near genocide of countless Native American nations, some more developed than others, each with its own unique culture, history, and socio-political organization. In order that such uncompromising brutality and devastation could occur, there was need of a dehumanization of the attitude towards such peoples beyond that normally found among conquerors towards the conquered, who often became assimilated among the very people they had vanquished. We shall see how racism was used to fill this need. But first, it would be helpful to ask the question: what was the character of those who came to the U.S. territory from their homes and families in Europe?

The settlers flocking to America from England, Ireland, Germany and Scandinavia in the first great wave of American immigration could not have escaped an awareness that they were seizing the lands and wealth of others, others whom at first had welcomed them pacifically, had even on many occasions given them shelter. Indeed, this very welcome often served to make successful extermination of the Native Americans possible or tempting. The settlers, if not racist in the beginning, would have to use racism or become racist in order to justify and make acceptable to themselves, their European allies, families and supporters, the enormity of the inhumane deeds they would perform. What kind of people were they, then, who, unlike their brothers in Europe, were not brought to their barbaric deeds by virtue of impressment in great feudal armies, etc.?

While it is commonly agreed that immigration to the U.S. was motivated by a desire to escape religious persecution, poverty, or the devastations of the endless wars in Europe, a majority of those so afflicted remained with their homes and families. What characterized those who left? As Charles A. Beard has observed:

Countless men and women who lived amid the wars, persecutions and poverty of the Old World and suffered from them as did the emigrants, stayed at home and continued to endure them. If the Old World backgrounds in themselves had supplied the sole motives for migration, then more millions would also have broken away and joined the voyagers bound for the New World. It followed, therefore, that there was something in the spirit of the men and women who voluntarily made the break and migrated, a force of character not simply determined by economic, political or religious conditions -- a force that made them different from their neighbors who remained in the turmoil and poverty of the Old World.56

While Beard goes on to suggest that this quality was one of enterprise and daring, historical analysis of their deeds seems equally to suggest a darker, almost buccaneering side to their character. After all, the very earliest immigrants to America were the kind of people who saw no ill in wresting the riches of land and resources (mineral, agricultural and forestry) from another people (the Native Americans) through force of arms, and had slight compunction with regard to exploitation of the labour of another race of people conveniently deemed inherently inferior (the enslaved Africans). That this search for fabulous riches, the "plantation or conquistador spirit" motivated the Europeans who settled in Africa, India and elsewhere is little questioned; that it should remain so obscured from view in relation to those who came to America can only be attributed to the U.S.'s success in purveying its national myths.

While masses of European immigrants to the U.S. were undoubtedly motivated by a flight from poverty and a natural desire to improve their situation, it is nonetheless true that the creation of the American Dream and the depictions of wealth and individual prosperity said to be possible in the U.S. proved a powerful incentive. Who can say that the humblest of immigrants didn't harbor dreams of great wealth? Why should such be possible in the U.S. and not elsewhere, if not for the reason that by virtue of their white skin and appropriate features alone, Europeans in America would have access to land and to exploitation of subservient non-European peoples?

The land to which the immigrants were enticed was promoted as being "virgin", unowned, just waiting for exploitation, much as in the 20th century, Palestine was said to be "a land without people for a people without land", in order that appropriate immigration might be encouraged. As noted by Charles M. Andrews:

Thus land-hunger and the desire for a greater amount of property-freedom were among the powerful inducements that drove a restless awakening people to migration overseas...All classes of the population in cities and boroughs and notably along the eastern and southern coasts from East Anglia to the West Country were stirred to their innermost souls by the visions of wealth and the tales of a sumptuously bountiful nature that were told by those who sent letters back from America or returned from ocean voyages thither. 57

The lure of the American Dream existed from the beginning, and indeed, still exists today. Undoubtedly, fortunes were made and great prosperity enjoyed by some from the opportunities afforded by Native American land and enslaved African labor. But for the vast majority, especially by the 1860's when all available lands had been dispossesed from the Native Americans, the possibility of great or even modest wealth came to an end. That the stream of immigration continued, mostly of those simply willing to labor in cities or industries for a wage, indicates some likely change in the character of those who came. Most immigrants faced a life of poverty and hard labour.

Yet the American dream remained -- and what was it, recognized or not, but the opportunity to compete in a race with a head-start at least over those for whom it was understood that the society reserved the bottom echelon? Which of the American immigrant groups over the centuries has assumed, for example, that they would, as new Americans, begin life in America on a lower echelon of the totem pole than the African-Americans? Indeed, which has?

It is not our intention to suggest that all the types that came to the U.S. were of the buccaneering spirit of the early immigrants. It is, however, simple fact that the benefits to European populations of American implantation have far exceeded those accruing to US. national minorities. White nationalism served the purpose of encouraging large-scale immigration from Europe, and in so doing, America reinforced European racism in the world in a way that had never occurred before. It advertised the U.S. as a state to which any person with white skin, European ancestry and appropriate features could come and be rewarded by vast tracts of nearly free land, and by assimilation into the new privileged white socio-economic ethny which maintained dominance over large masses of colored peoples (African-American and later, Mexican American peoples upon whom would fall the "dirty work" of society, whose labor would be cheap and exploitable). They would be guaranteed socio-economic advantages coupled with psychological ones, since just the fact of being

European meant the opportunity for superior privileges, while being non-European meant lessened opportunity. Whether this was achieved and is still maintained through manipulation of morally inno- cent Anglo-Americanized masses by their elites, or whether it exists by unwritten, unspoken collusion between both parties for their rela- tive mutual benefit in minority exploitation and domination, the fact is that the anti-social contract was brought into existence.

Apart from the problem of enslaving and making an internal colony of the Africans, the ruling elites of the 13 colonies were also faced with the necessity of attracting large-scale European immigra- tion, so that the population of the U.S. would become preponderantly European. The early recourse to slave labour (since the Indians, having been decimated, either couldn't provide it, or tended to disappear into the bush, and since the European immi- grants had a tendency to strike out for their own fortune on rich Indian lands) was problematic. This is true not simply because slave labour was inefficient, but also because the swelling population of Africans threatened the definition of U.S. territory as European in population and tradition. By 1770, they were 21 percent of the total popula- tion[58] and over 50% in the most valuable and developed regions of the south. Increased European immigration was the answer.

The importance of this quest of early American settlers for land and mineral riches -- as opposed to for opportunity for honest labor and freedom from religious intolerance -- is also suggested by Amaury de Riencourt in his work, *The American Empire:*

...the closing of the West to settlements by the colonists was one of the decisive moves which brought about the American Revolution. The Royal Proclamation of October 7, 1763 emphasized: "We do strictly forbid, on pain of our displeasure, all our loving subjects from making any purchases or set- tlements whatever in that region." All the western land claims of the Thirteen Colonies were, *de facto,* wiped out at one stroke by London's deci- sion...London began to view the West as one vast reservation for Indians, to be run by an imperial Indian civil service for the ultimate benefit of an expanded fur trade.59

Central to the American Revolution, then, along with "no taxa- tion without representation", was the right to continued expansion into Indian territories, with its concomitant dispossession of Native Americans, who were not assimilated but rather herded onto unwanted territory (reservations). De Riencourt continues:

While they used the American Revolution to promote democratic and egalitarian reforms and to fight against the social evils from which they were suffering... they blended these democratic ideals with an innate and relentless expansionism...The American Revolution showed its true colors at the very beginning. The extralegal Congress which gathered in Philadelphia in September 1774 promptly proclaimed the "Suffolk Resolves," which included, among other demands, the creation of a continental legislature which would have full control over Indians and western land grants.60

However, as in a lottery, while the possibility or chance of achieving enormous wealth attracted the participation of large numbers, those who actually gained such riches were small in number. The American Dream lottery proved equally unrewarding for many of the later immigrant participants. By 1770, in Boston (in the Puritan heartland, founded on the efforts of small entrepreneurs, according to American mythology) the top 1 percent of property owners owned 44 percent of the wealth. In 17th century Maryland, while the first batches of servants became landowners and politically active in the colony, "by the second half of the century more than half the servants, even after ten years of freedom, remained landless. Servants became tenants, providing cheap labor for the large planters both during and after their servitude."61

The potential for revolt among impoverished Europeans, in combination with enslaved Africans, increased the necessity for ruling elites to emphasize white nationalism or the color line, to create a sense of community of interest among whites, an inter-class, inter-ethnic solidarity to be exercised for the benefit of all whites (though to the greater benefit, naturally, of the Anglo-Saxon elites), and at the expense of the national minorities. The appeal to whites by elites found institutional reflection. For example, it was about this time that slave codes involving discipline and punishment were passed by the Virginia Assembly.

Virginia's ruling class, having proclaimed that all white men were superior to black, went on to offer their social (but white) inferiors a number of benefits previously denied them. In 1705 a law was passed requiring masters to provide white servants whose indenture time was up with ten bushels of corn, thirty shillings, and a gun, while women servants were to get 15 bushels of corn and forty shillings. Also, the newly freed servants were to get 50 acres of land.62

Not only did the elites hold out the temptation of superior status for poor whites; they also elaborated a system for the legal and social

punishment of black and white collaboration.[63] Whites could carry arms, while blacks could not. The distinctions of status between white and black servants became more and more clear. When the incentives to immigration promoted by the ideology of white nationalism did not provide sufficient immigration to offset the increasingly dangerous numerical increase among enslaved Africans, the ruling elites achieved the passage in the English parliament, in 1717, of the sentence of transportation to the New World as a legal punishment for crime. After that, tens of thousands of white English convicts were sent to Virginia, Maryland and other colonies.

Indeed, the question of the future of the enslaved Africans was to become ever more pressing, even should they not succeed in combining their interests with poor whites:

The question became particularly urgent by the early 1840's because of developments during the previous decade. Nat Turner's rebellion, the spread of radical abolitionism and the outbreak of racially inspired riots in the North; the emergence of the Liberty party; the failure of the federal and state governments to develop a program to colonize substantial numbers of manumitted blacks in Liberia -- all of these combined to arouse apprehensions among white leaders who had searched unsuccessfully for a solution to the vexatious racial problem.64

One solution proposed was the annexation of Texas, to provide a conduit for the removal of freed and/or escaping Africans to Central and South America.

Many prominent politicians and publicists regarded the nation's black population as a menace to American security and promoted the annexation of Texas as a simple solution to a complex problem. Unwilling to accept a future that would include blacks, whether slave or free, as permanent inhabitants of the Republic, the expansionists viewed Texas as a potential outlet for their country's unwanted black population. 65

America's ruling elites, even during the period of continental expansionism, continued to be plagued by the contradictory aims of acquisitive seizure of the wealth and/or labor of the national minorities and the desire to create and maintain an ethnically homogeneous (ie. Anglo-Saxonized) population in America. The existence of non-European populations (Indians, enslaved Africans and later, Mexicans) prodded them one direction, then the next. The expansionist buccaneering spirit that swallowed up the land of the Indians was,

after Independence, turned in another direction: towards lands held in the New World by France and Spain, as part of, as President James Polk expressed it, the "Manifest Destiny" of the U.S..[66] The acquisitiveness and rapacity that marked the expansionism of U.S. settlers found its institutionalized reflection in the policy decisions of all echelons of U.S. government. But the need to maintain racial homogeneity (another way of putting Anglo-Saxon racial dominance) remained an active conscious determinant of policy.

Preoccupied with attaining racial homogeneity in the United States, the expansionists looked forward to the time when blacks, Indians, and Mexicans would completely disappear from the continent and whites would take sole possession of it... expansionists generally contemplated in their calculations not only the land that would be acquired, but also the quantity and quality of the population inhabiting it. Expansionists wanted regions such as Texas, Oregon, or California, where Anglo-Americans already predominated, or where their migration would soon eclipse the native inhabitants. But when a more concentrated nonwhite population inhabited an area, as in Mexico below the Rio Grande or in Cuba, enthusiasm waned because of fears about amalgamation and racial conflict... White racism {white nationalism} could act as either a stimulus or a deterrent to the country's extension, depending on the size of an area, the racial composition of its inhabitants, and the density of its population.67

The growing labor movement, under the influence of the white nationalist ideology, did not combat the plight of African-Americans, enslaved or otherwise. It turned them away, then was faced with their use as strikebreakers.

By 1869, most unions still kept Negroes out, or asked them to form their own locals. ..In general, the Negro was kept out of the trade union movement. W.E.B. Du Bois wrote in 1913: "The net result of all this has been to convince the American Negro that his greatest enemy is not the employer who robs him, but his fellow white workingman."68

By the 1890's, the dispossession of Indian lands was almost complete; there were no more Native American lands to entice new immigration. Yet, commencing around 1860, and continuing thereafter in increasing tides, the second major wave of immigration to America took place. While this immigration was resisted by organized labor consisting of first wave immigrants (English, Irish, German and Scandinavians), it was actively promoted by American railway

interests which transported trainloads of immigrants to the West, by employers ever struggling to keep wages low even among white workers, and a horde of "labor bosses" who profited by supplying laborers of their national origins to big industries. As Charles Beard noted:

In Europe these agents gave to prospective emigrants a rosy view of the money they could quickly make in the United States.. a considerable portion of {immigration} was artificially stimulated by "quasi labour agents" and by the "many thousands of steamship ticket agents and sub-agents operating in the emigrant-furnishing districts of southern and eastern Europe." In other words, the commission found that, apart from the actions of former immigrants settled in the United States, the promotion of immigration had become a money-making game highly profitable to those engaged in it. 69

What might this phenomenon represent, but a likely source of the continuance of the mythical American Dream, first created in the 16th century by the prospect of endless "virgin" land or cheap slave labour ripe for exploitation, and later in the 20th century consolidated by all the glamour and wealth achieved from this exploitation and displayed through American movies and television. Lures dangled to entice susceptible illiterate peasants to leave family and homeland and voyage into the unknown -- to the profit of the steamship companies that transported them, and exploitive employers in the new land -- stimulated a vision of the promise of America both in European and American popular culture rarely traced to its more taudry sources. However, by the time of the arrival of this second wave of immigrants, all the Native American lands had been dispossessed; the little man's chance at high stakes was over.

It is often argued that the new waves of immigrants, speaking other languages and predominantly Catholic, had intentionally been sought as a natural means of splitting the existing labouring classes which had just begun to successfully organize, through their provision of cheaper labour and their use as strikebreakers.

The New Emigrants not only would work for less than the sons of the Old, but were less likely to organize in their own interests. Their immunity to organizers' efforts could be prolonged by deliberate adoption of a policy of balanced nationalities -- getting as many ethnic groups as possible on the payroll, keeping each relatively small, none large enough to overbalance the others. Thus the language barriers exerted optimum usefulness as preventers of fellow feeling.70

And accordingly, much of organized labor and many reform leaders opposed the unrestricted importation of eastern European immigrants, an importation supported by the National Association of Manufacturers "and many a candidly reactionary individual industrialist."[71]

However, of prime interest is the Anglo-American racist tactic used at this period to implement White Nationalism. As the Anglo-Americanized ethny attracted, then absorbed, other white nationalities to participate in the plunder of the American national minorities (Natives, free and enslaved Africans, and Mexicans), the other white nationalities whose cheap labour was sought to play this role were sought predominantly in European countries. In fact, the Chinese, who had earlier been frequently imported to provide cheap labour, were kept out of the country by the enactment of the Chinese Exclusion Act in 1882, marking the commencement of restrictions on immigration. The stream of immigrants that flooded the U.S. had been subject to no retarding *legal* restrictions of any kind until the passage of this act, thus establishing nationality as a major factor in the commencement of immigration controls.

Given the mixtures of language, culture and religion among the new wave of immigrants (from Italy, Austria-Hungary and Russia), the new immigrants held in common with the ruling elites and the first wave of immigrants only their white skin. As President Theodore Roosevelt was to point out in his Annual Message to Congress in 1905:

...we cannot have too much immigration of the right sort and we should have none whatever of the wrong sort. Of course, it is desirable that even the right kind of immigration should be properly distributed in this country. We need more of such immigration for the South, and special effort should be made to secure it. Perhaps it would be possible to limit the number of immigrants allowed to come in any one year to New York and other Northern cities, while leaving unlimited the number allowed to come to the South: always provided, however, that a stricter effort is made to see that only immigrants of the right kind come to our country anywhere.[72]

Why should the South be especially singled out in its need for immigrant population "of the right kind", but to implicitly emphasize the desirability of having an increased white population to outweigh the large African-American Southern population which in many areas vastly outnumbered the Anglo-American population. Also, the

mention of restricting immigration to New York and spreading it more evenly over the country is nothing more than a more subtle way of assuring that the new immigrants would not be able to preserve their language and cultural and social identity, and would become appropriately Anglo-Americanized. *By their experience with mixing or spreading the African from one area or nation among Africans from different tribes and nations, the earlier settlers had learned the art of Anglo-Americanizing foreign populations.*

Increasing the ballast of a unified white population against potential African-American revolt or numerical superiority in the South, by attracting European immigration posed another equally difficult question. After all, the conquerors of the U.S. territories were British, but English and Irish immigration had begun to ebb. Since England could not be expected to provide all the population needed, how could large numbers of other Europeans be brought in without upsetting the Anglo-Saxon politico-cultural dominance? (Indeed, when the numbers arriving from western Europe in the years 1901-1910 were a mere 2,000,000 compared to the 6,100,000 coming from Eastern Europe,[73] immigration controls against these later immigrants, as apparent above, were enacted, in the fear that such numbers might prove unabsorbable, within the context of securing an Anglo-Saxonized or Anglo-American nation.)

It was to meet these challenges that the concept of white nationalism evolved out of that of simple racism. It billed the U.S. as the territory witnessing the creation of a new white ethny melded from the many ethnies of Europe, an "American" ethny whose members would acquiesce to being Anglo-Saxonized for the benefits of becoming Americans. This was a brilliant notion, if for no other reason than it conceptualized that white skin and certain other features were the only links all the ethnies in Europe had in common, and attempted to unite them into one race in the U.S. on that basis. By camouflaging the Anglo-Saxonizing process behind the notion of a privileged white race or white nation brewed in the melting pot, non-British Europeans were able to convince themselves (at the very time that they surrendered their unique ethnic and racial heritage), that they were privileged to be able to do so, and were also somehow helping to create and contribute to the definition of what an American was, although, as J.C. Furnas noted:

...thanks to mutual mistrust hardened by purveyors of new nationalism and old prejudices, America's general ways-of-doing have had little enrich-

ment from the New Emigration, nothing like what came from the Irish or Germans of the previous inflow.74

We note, here, the presumption that the body of that identity was necessarily Anglo-Saxon, as the other ethnicities of the first wave (Irish, German, Scandinavian) merely *enriched* that identity. Viewed from hindsight, the type of flim-flam used to enlarge the Anglo-American ethny in the U.S. resembles more a "Mission Impossible" series on TV.

That the right population was predominantly white, and preferably Anglo-Saxon and/or Protestant, became visible in the written enactment of this white nationalist anti-social contract principle in immigration quotas established by the 1920's.

By the 1920's, Congress had established laws setting immigration quotas: the quotas favored Anglo-Saxons, kept out black and yellow people, limited severely the coming of Latins, Slavs, Jews. No African country could send more than 100 people; 100 was the limit for China, for Bulgaria, for Palestine; 34,007 could come from England or Northern Ireland, but only 3,845 from Italy; 51,227 from Germany, but only 124 from Lithuania; 28, 567 from the Irish Free State, but only 2,248 from Russia.75

However, what becomes apparent is the limits of white nationalism. While the Anglo-American ruling elite felt secure in attracting white immigrants from populations with significant cultural differences to the mainly Teutonic first wave, this was only to the degree that they felt that same immigration might be absorbed or assimilated or Anglo-Americanized. Should the populations in that ethnic group become sufficiently large as to be competitive with the pre-existent Anglo-Americanized population, Anglo-Saxon dominance might have come into question. And accordingly we see, reflected in the import quotas above, as Slavic immigration had begun to far outpace that from western Europe, that immigration quotas were instituted against them as well. This is true although they were, biologically, "white."

Thus the original Anglo-Saxon ruling elites were able to establish and maintain Anglo-Saxon dominance over American institutions, despite the large importation of Europeans of other ethnic backgrounds. The key was a good assimilable numerical balance: enough white population to assure the white population's dominance in America; not too much white population from eastern Europe, in

case that population, by nearing numerical competitivity with the Anglo-Saxons and Anglo-Saxonized (ie. Irish, German and Scandinavian) precursors, should be able to successfully resist assimilation into the earlier group, and an avoidance, either through immigration policy, or judicious expansionism west and south, of the incorporation of more non-European populations into the body politic.

Most instrumental in the establishment of a policy of Anglo-Americanization of the old and anticipated new waves of immigrants was the initiation of universal free public schools. This original and perhaps continuing mission of the U.S. educational system -- to Anglo-Saxonize at all costs -- may even today be the chief reason for the difficulties African, Native and Mexican Americans are having in educating their populations.

Immigration was likewise brought into the pleas for free and universal education. Seeming thousands of men, women and children were arriving in America from foreign lands. Many of them were unacquainted with the *English language* {italics added} and with the arts of self-government. Among them was a large proportion of Catholics; and Protestants feared that the Catholics would gain too much power in politics and public affairs generally if they were not "Americanized."[76]

The *American* identity which the foreigners were to assume simply happened to concern the English language and the Protestant religion. Cultural homogeneity was to be established at the cost of their language, at minimum. It was up to the schools to create and purvey the national history, and indeed, the national myths. The plan proceeded slowly, with much assistance from government legislation and public funds, indicative of strong ruling elite support.[77] As Charles Beard noted:

Grudgingly, stone by stone, amid the grumblings of taxpayers, the foundations of the system of free public education were laid in all the Northern states and in several Southern states by 1860. According to official estimates for that year every *white* {italics added} inhabitant of the country received, in public or private schools, on the average, more than five times as many days of schooling as such inhabitants received in 1800.

The populations to be "Americanized" in the early formative years of the U.S. education system were white, despite the existence of black populations in the North no longer under the emprise of slavery. The cultural homogeneity to be established was simply

exclusive of northern and southern black populations, and indeed, against them. By the time it became the turn of the black population to become "Americanized", the system was completely formed and in place. "Americanization" for them would mean acceptance of the inferiority of their race, culture, lifestyle, etc., and indeed of their socio-economic and political position in the U.S. *vis-a-vis* the new white ethny.

The swift re-establishment of white and black separation in the South by means of the Jim Crow laws and Black Codes that legally entrenched the American system of apartheid known as segregation despite Civil War cooperation of southern blacks with the Northern government confirmed the willingness, if not indeed the desire, of Anglo-American elites in the North as much as in the South to maintain white nationalist collusion to the detriment, exclusion and exploitation of the African-American national minority. The black "melting pot" had begun on the Island of Goree in Senegal, and the continuation of this melting pot in the U.S. would create a second American race -- the African-American, who would be inferior and subservient to the race created in the white "melting pot". However, both would be brought to voluntarily submit to the cultural and politico-economic dominance of the Anglo-Saxon race.

For a period of more than 7 decades, the once-enslaved Africans and their descendants lived in the South in a condition billed as "separate but equal". It wasn't until 1954, when African-American protest combined with developments in the international arena, that the U.S. government was led to effectively accept the legal citizenship of the African-American population. Historical geo-political changes had, by this time, permitted the white ethny in the U.S. to secure a numerical majority in all significant geo-political areas before pressure from the Civil Rights Movement and the United Nations obliged the government to assure the right of the African-Americans to vote and hold office.

In important areas of the South such as Mississippi, where this was not the case, the white ethny resorted to new politico-economic or terrorist tactics to encourage African-American movement into areas of the northern U.S. where their numbers would be politically insignificant, thus assuring that their numbers in the South would be significantly reduced. When this process of balancing the populations to suit the maintenance of Anglo-American political dominance in each state was achieved,[78] the right of African-Americans to participate in the voting process became a reality, though obviously a

relatively meaningless one. Today, in national elections, the boycott of the polls by African-Americans would probably be more politically effective than their use of the election process.

We might turn to a parallel to shed greater light on the significance of this achievement: the case of South Africa (whose constitution is almost the same as that of the U.S., and whose apartheid legislation drew inspiration from the Jim Crow laws which established segregation or American apartheid in the southern U.S.), where the international process of African decolonization occurred before the population of the white ethny in the South African state could be sufficiently enlarged. The premature demand for majority rule by black South Africans caught the white South African ethny unprepared. In its constitutional theory, South Africa has always upheld majority rule, as has the U.S.. However, effective demand for majority rule arrived before the white ethny was numerically the majority; thus the white ethny, in order to maintain its political dominance, has had to deviate from the U.S. model by creating the so-called independent black republics in South Africa, so that the white ethny might be numerically dominant in the republic that rules the real territory and economic resources of the country. WhiteSouth Africa and the *pieds noirs* of Algeria seem to be examples of white nationalism modeled on the U.S.'s relatively successful example, which have failed to achieve international credibility as having created a legitimate freedom-loving democracy for the people and by the people.

White nationalism in the U.S. has continued, since its inception, to entice Europeans to the U.S. from both the west and eventually the east, thereby assuring a widespread European support for the U.S. system, and particularly for its position regarding the best and most likely course of action to gain their freedom and development that should be followed by African-Americans and other U.S. minorities. In essence both the east and west are saying to the American minorities "you have nothing to gain or to offer by upsetting the American applecart. We all admire the American melting pot. So be good and do not seek self-determination like all other oppressed nations; instead, demand better treatment." This advice reflects the success of U.S. propaganda in convincing the world that African-Americans really are a different kind of nation that do not really want or need to be free, that somehow they are being civilized or developed by their oppression.

The international socio-cultural, economic and political success of U.S. white nationalism has projected it onto the international stage

in such a manner as to encourage other nations to revise their historical, cultural and political orientation towards Africans, and particularly African-Americans, so as to minimize favorable African images and to maximize their connection or closeness to the ideals of white nationalism. The Latin American countries which the U.S. has periodically occupied, were particularly affected by the ideals of white nationalism, to the extent that its concepts and slogans are routinized in the day to day life of almost every Latin American country, with the notable exception of Cuba and Nicaragua, where a pre-existing anti-social contract has been purposely and systematically abandoned. In Canada, white nationalism against U.S. minorities remains pragmatiically the order of the day, although Canadians approach the resolution of their own minority problem outside of this framework -- self-determination for the Indian in the North, biculturalism in relation to the Quebec minority and multiculturalism in relation to Africans and other smaller minorities. It is when Canadians glance towards a solution to the situation of U.S. minorities that the influence of U.S. white nationalism becomes manifest.

Other states conform by not highlighting for the benefit and education of their citizens, the history or existence of great black kings and leaders in Islamic history such as Mansa, Musa, Sundiata, Abu Zaid, Ansar, etc. who made significant contributiosn to mankind's development.. The Southern Europeans conform to the success of U.S. white nationalism by highlighting the rootless or servant side of the Moors and other Africans who ruled in Europe, ignoring their many cultural, scientific and philosophical contributions, etc..

Some elites in the African countries have also attempted to conform, even though they are Africans. They attempt to side-step the effect of U.S. white nationalist projections by attempting to isolate its effects from themselves while seeking a way to cooperate and avoid isolation while achieving economic benefits. Thus they (particularly in the Anglophone civilization) point to the Americanisms of white nationalism (often mistaken for racism) and cooperate by attempting to disassociate themselves from the African-Americans about whom they are willing to believe the U.S. ideas may apply.

The U.S. productive and human rights model is too beneficial to be upset even if its success depends on maintaining American minorities' imprisonment. The U.S. system as is today benefits elites everywhere. Even today in socialist countries such as Poland, Yugoslavia or Czechoslovakia, the U.S. position in relation to its minorities

still demands respect and credibility among the populations (as opposed to in government echelons) while a similar exploitation of Africans in South Africa lacks all credibility. The power of the U.S. plus the effect of having so many citizens of eastern European descent serves in many ways to hold popular opinion in many countries hostage.

Let us now elaborate some of the factors that have either helped to create, reinforce, and/or continue to this day to maintain the notion of white nationalism, which has become identical to the components of the American image.

American Racism

We have seen the absolute importance of racism as a tool to justify the wresting of the territories of North America from the hands of its aboriginal owners, and how racism gradually evolved as the tool used to galvanize European peoples for the development of white nationalism. As the implementing agent of white nationalism (and a major factor in the maintenance of white nationalism), its presence is felt in every corner of American life -- even in areas where the question of minority and majority conflicting economic interests may not seem to be at issue.

In keeping with the needs of the anti-social contract, racism in the U.S. is promoted and maintained through a variety of ever-changing epithets of confirmation: the haves and the have-nots, the winners and losers, the yuppies and the underclass; the powerless and the movers and shakers, the wealthy and the poor, the homeless and the homeowners, the inner-city and the suburbs. One is always good and the other always bad. One is always composed chiefly of the white ethny, and the other chiefly of the minorities. All the categories and symbols that the U.S. uses to define its society and institutions serve equally to confirm and support the U.S. historical maxim so crucial to the *raison d'être* of white nationalism: that whites are superior to blacks, that (Anglo-Saxonized) Americans are racially superior to all other white races.

Thus racism in the U.S. anti-social contract is not *"peur des autres"* but an historically developed system of ordering and orientating U.S. society in keeping with the myth of racial superiority and racial inferiority, from which derives the most important notion of the right of the superior to dominate the inferior. In the truest sense,

even the U.S. concept of majority rule is interwoven with the right of the Anglo-Americans to rule. Historically, particularly in the South, we have seen numerous occasions wherein the concept of majority rule was totally alien to Anglo-American actions until such time as they were able to secure an Anglo-American majority.

U.S. minorities are portrayed as the problematic element of the Anglo-American nation: the black element, the poor element, the underclass. For the purpose of their continued politico-cultural domination, their right to be different from the Anglo-Americans, in the way that their history and culture has made them different, is totally denied.

U.S. Philosophical Traditions

It is a feature of the anti-social contract that certain philosophies and historical traditions are emphasized at the expense of those which will not accommodate minority oppression within the framework of mainstream democracy. Of great assistance to the U.S. ruling elites in morally justifying their way of dealing with minorities (the anti-social contract) was the western and particularly English philosophical and historical tradition to which the U.S. ruling elite belonged, and which came to be shared by most other white and often middle class black American citizens. Accordingly, American historiography too looks back with great approval to ancient Greek democracy, which is admired and celebrated without emphasizing -- indeed, barely pointing out -- the existence of Greek slaves, whose exploitation made Greek democracy economically feasible. A gaping hole exists in the U.S. historic teachings during the period of eminence of the Islamic civilization, a civilization widely acknowledged to exhibit exemplary tolerance for its minorities. American historical philosophical emphasis travels from Greece to Rome, then jumps across the Dark Ages of Europe to celebrate the European renascence, with little regard for the contributions of the Arab and African world that helped to make that reawakening possible.

So, too, the American ruling elites drew from the political tradition of the ruling elites of Britain, a nation whose social philosophy had come to both encourage and defend its development, through slavery and colonialism, of a crushing hold on the Third World so extensive that the sun was said never to set on its empire. A nation which had recoiled in horror from the egalitarian principles of the French Revolution, and was, until mid-twentieth century, the primary

proponent of capitalism worldwide. Even today, this same nation recoils in horror from the continental social democracy. Indicative of the British enthusiasm for democratic participation with non-European peoples was the frigid relation of the British colonials to Indian nationals, and later, the decision to surrender government of India to the Hindus, an ethny that maintained the world's oldest, most severe and oppressive form of social hierarchy, the caste system.

As noted, the English philosophers such as Locke and Hobbes had always given the maintenance of authority, political control and order an exceptionally higher value than the idea of free expression of the masses, and unlike Rousseau, they never dreamt of direct democracy in which the masses might participate directly in decision-making.

But most important, in terms of European influence *vis-a-vis* American national minorities, were the negatives images of Africans historically popularized in Europe. Mr. Jan Nederveen Pieterse has graciously presented us with an image analysis in his booklet *White on Black: Images of Blacks in Western Culture,* which is published in complement to the Exhibition of the Negrophilia Collection appearing in the Tropenmuseum Amsterdam, December 16, 1989 through August 21, 1990:

Knowledge is power and so are images, as a form of knowledge, a mode of ordering the world. The images {of the colonist of blacks and Indians, etc.} although naive, were not so innocent... They may be called 'racist' but even that is an understatement. They may be interpreted as popularizations of 18th and 19th century 'race science', but even race science and the racial theories of the 19th century are but episodes in a much more extensive process of {'ordering',} of thinking Europe on top of the world at the expense of other peoples and continents. Of course it is true that these images are 'racist', that they are emblems of imperialism and colonialism; but to what extent is to interpret them in this way also to categorize them away, to neutralize their meaning at a time when colonialism is past and racism taboo? Would it not be appropriate to keep in mind that racism and imperialism, as manifestations of western culture, raise the larger issue of western culture itself?

Viewing the various stereotypes of Africa and blacks {involves highlighting the negative side of ideas} going back to the classics, the Bible, the middle ages, the Renaissance, and the amalgamation and distortion of these legacies during the Enlightenment and after. The self-image of Europe took shape in relation to 'Others', be it the Orient, Africa, America or the South Sea. Images of Others are woven into the fabric of western cultural identity.

{When we look back at the 18th and 19th century European conceptions of Africa}, we view western culture in one of its unguarded moments. It was a view for domestic consumption, not intended to be shared with the objects of this depiction, at any rate, in most cases, not aimed at them. These were images by and for whites about blacks { in a similar way to which the U.S. Constitution, Declaration of Independence, etc. were by and for whites, although they involved blacks.} Accordingly, what is significant about them is not what they say about blacks or Africa, but rather what these images imply about {Europeans}, what they intimate about western belief systems... It is the relationships between whites and blacks as represented by whites. The issue is power and stereotyping. How do relationships of domination find expression in everyday culture? How are they normalized and routinized in word and image? By what processes are the dominated identified, labeled, kept in line? How do caricature and stereotype, humor and parody operate as instruments of oppression? The rhetoric of image and the politics of repression in European history is the master's view of master/servant relationships... It is 'servants' who are depicted but it is the mentality of the 'masters,' makers and beholders of these representations, who are revealed...

The image of the world of the four continents became customary in the 16th century. The continents were frequently personified as female figures. In many pictorial representations from the 17th into the 20th century, the figure personifying Europe and/or a European country or city (e.g. Brittania, Amsterdam) is shown in the center of the picture, regally crowned and throned, with the other continents at her feet offering their wares. These image are concise emblems of European power and narcissistic imagination.

Race science took shape in the 18th century. It followed a period of ethnographic confusion. As can be seen in many representations of the time, Europeans did not really know what the peoples of other continents looked like. They were often shown in outlandish costume but with European facial features, or they were mixed up -- Native Americans with black skins, or blacks with feathers. 'Race science' attempted to arrive at classifications of types of human beings ('races') based on measurement. This was fused with older ideas as to the location of different types in relation to the Chain of Being, or on the evolutionary ladder, according to a later terminology. Did certain 'races' stand closer to nature than others? Did all human beings stem from the same creation of God, or were there multiple creations? {These and other questions were being asked in Europe more than one thousand years after both Jesus (PBUH) and the Prophet Muhammad (PBUH) had declared all men equal and sons of Adam}

These questions were not merely problems for science, but also had acute and wide-ranging concrete and political significance. The backdrop of the development of 'race science' was the slave trade. The 18th century also witnessed the beginnings of the slavery debate. The classification of

human types, and hence their image and representation was, in part, political .

Savages paraded through European imagination as imagined counterpoints to the world of civilization -- noble according to Montaigne, good as with Rousseau, as Caliban (anagram of cannibal) with Shakespeare. The iconography of Africans as savages tended to show them in 'wild' natural environment, scantily clad, without tools - 'but one degree removed from the level of brute creation'. Notions associated with savagery ranged from noble virtues to aggressiveness, lack of emotional control, lack of (agri)cullture. Texts associating Africans with animals were more common in the 19th century than in the 18th. Is it too farfetched to assume that in a number of cases pro-slavery propaganda was at work, ie. deliberate counter propaganda to the 'Am I not a man and thy brother' view of the abolitionists"? It is obvious that texts and images stating or insinuating ape-like features of blacks were the most anti-emancipatory kind of propaganda...

With this set of images a new series begins: the European presence in Africa. Henceforth we see images of Africans juxtaposed to Europeans in Africa. Classic are the images of Livingstone and Stanley trekking through wild landscapes followed by a row of porters. Classic is the scene of their meeting -- 'Dr. Livingstone, I presume'. European explorers are the heroes of this genre, but what if the focus shifts to the Africans in these pictures: they are reduced to mere extras in a European fantasy {similar to the African and Native Americans on contemporary American television}. A Dark Continent according to the fantasy, penetrated by heroic torchbearers of civilization ...

The role missionary activities played in paving the way for and later in many instances as instruments of colonialism is well known. Here we find amongst other themes the dual image of Africans as heathens on the one hand, and on the other, as the result of missionaries' efforts, christianized Africans. Heathen Africans were demonized in the missionary propaganda intended for home consumption -- a recurrent image was the evil witchdoctor; this demonization sanctioned the necessity and urgency of the mission. To sanctify itself, the mission diabolized Africa...

The contrast 'African warriors'/'European soldiers' plays a striking part in the depictions of colonial wars. In these mostly propagandistic representations, Africans are also implicitly represented as waging battle against civilization... Scenes through which colonialism was popularized include native dignitaries bending in the dust before representatives of European authority, edifying depictions of productive labour in the colonies under European supervision, and images of personal service rendered to Europeans.

...Western imagery soon progressed beyond the generalities of barbarians, savages, beyond the mere concept of races, and dealt in terms of peoples. Descriptions of customs-and-manners were the substance of such ethnographic knowledge {of the colonial era}. More detailed than mere

racial prejudice, it was this illusion of knowledge on which colonial administration could base itself. {Similarly, the Anglo-American ethny of today still claims complete knowledge of African-Americans -- of who they are, and what they want., etc. without ever dreaming of the need for a referendum or plebiscite to democratically determine their desires or needs.}

To bring civilization was the stated objective of colonialism, while at the same time the colonized peoples were routinely stereotyped as irremediable savages living in a 'state of nature' -- {much as in contemporary America, where the stated objective is to educate African Americans who are pictured as irremediable criminals, entertainers and athletes unacquainted with any of the more humane affections, living in ghettoes where only the rules of nature apply.} This antinomy of expectations engendered frictions which could be solved by humor -- humor, of course, at the expense of Africans, whose laughable imitations of European names, customs, speech, dress, lifestyles were a running gag in European reflections on the colonial world .

All this proved to Europeans that their 'civilizing mission' would never be over and their hegemony would be everlasting. {just as today, the search by African-Americans to be the same as Anglo-Americans provides the Anglo-Americans with the role of forever being masters of this never-ending process.}

{Segregation in the U.S. and apartheid in South Africa stood apart from other forms of colonialism. They were} the most urgent cases of applied racism. *Historically, South Africa and the U.S. played a key role in the development of European images of Africa. For more than two hundred years they were the main sites of European settlement in the new world and sub-Saharan Africa, and thus the main source of European information.* {italics added} The earliest modern European ethnography of Africans concerns 'Hottentots' (Xhosa) and 'Bushmen' (San), { and eventually would include American negroes.}...

Westerners who venture into the hands of the savages are bound to end up in the cooking pot to be prepared, with appropriate herbs if they are lucky, for consumption by cannibals. This has been the most worn-out cliche and popular joke in the West for over a 100 years. Its historical roots may be the classical and medieval monster tales, which acquired a new lease of life with spicy stories of 'discovery from the 16th century on.

The ironization of this theme dates from the turn of the 19th century with the notion of cannibalism as a form of gastronomy. When the bitter and bloody wars of colonialism were past, the cannibal theme no longer served to express threat and fright, but became humorous, centered on the idea of the savage gourmand. Savage and therefore a cannibal but also with refined cuisine manners. This new image of the cannibal gourmand became the icon of the colonized savage and domesticated, pacified Africa. It shows westernization in the attributes of cannibalism and at the same time it says: nothing has basically changed; underneath their western dress, Africans are still savages.

Thus this icon serves as a bridge between old and new images of Africans and endorses the colonial civilization myth. It bridges contradictory European fantasies and confirms westerners in their belief that Africans are still savages in heart, still inferior human beings, justifying neocolonialism {or unequal status/forced assimilation, as is the case in the U.S..}

{The U.S. institution of enslavement of Africans} was not itself a particularly popular theme of image productions. There were depictions of course of the transport of enslaved Africans, of Africans on auction, at work and at play, but it was abolitionism that was rich in image production rather than the 'peculiar institution' itself. Most of the familiar images of slavery are images produced from the point of view of abolitionism. They portrayed African-Americans as fellow human beings {but}... as docile and suffering victims {who had no worthwhile culture, and were desirous only of assimilating and being taken care of.} *Uncle Tom,* after the classic novel of abolitionism, is the prototype of this victim image. In reaction to abolitionism, the proslavery lobby in the United States... produced new denigrating depictions of {Africans in the U.S.} The child/savage image of {Africans in the U.S.} served as a cultural barrier against real emancipation. When {the U.S. concept of} Emancipation did come, it was not the same as equality or the end of applied racism {domestic colonialism}.

{Two types of images of Africans emanating from the U.S. itself had great influence in formulating the depiction of Africans prevalent in European culture: that of Africans} as *servants* and as *entertainers.* For a long time these were the only two 'permitted' or widely accepted depictions of Africans in the western world. {The political, economic and social ramifications of this is still fairly obvious.} Many other images, for instance in advertising, are but variations on these key themes.

From continental Europe, the image of the African servant had a different history. He is the *black Moor* of Mediterranean tradition, as luxury item and status symbol in the service of aristocratic and rich families, in quasi-oriental costume (striped trousers, turban). A different type of African servant, not necessarily in Moorish costume, is an emblem of colonial wealth from the West Indies or Africa, or wealth from trade in enslaved Africans...

The Minstrel, one of the major African entertainer images, originates in a tradition of putting African people in the American South down by ridiculing them. Satire and humor were used as instruments of a counter abolitionist, {and counter-revolutionary} effort of 'putting the {Africans} back in their place'.

The desegregation of sports took place from the late 19th century on and continues today, in particular as regards management positions in the sports world. When {Africans in the U.S.} broke through the color barrier in cycling, boxing, running and so on, the sports arena was turned into an arena of racial contest, and while it shattered some prejudices against blacks, it was taken as confirmation of others ('all brawn and no brains.')

Some stereotypes of blacks are known by name, as types within stereotypes...The United States knows many such types, some with a background in slavery such as *Sambo* and *Rastus* (antidotes to the threatening figure of the rebellious {Muslims and Africans}, some with an abolitionist background like *Uncle Tom,* some with a counter abolitionist origin like *Jim Crow,* and some of the period after Emancipation like *Uncle Remus.* In England, the most wellknown black figure is the *Golliwog,* a doll derived from the United States and made a commercial emblem by Robertson's Marmelade Company. In France, *Banania* was modeled on a Senegalese infantry soldier serving in the French army, advertising a breakfast product made of chocolate flavored banana flour. In Germany, the most familiar black figure in popular culture is the *Sarotti Mohr,* the little black servant bringing Sasrotti chocolates in use as a commercial emblem since 1911. In the Netherlands, the most prominent black figure in popular culture is *Zwarte Piet,* the black servant of Saint Nicholas.

This parade of popular African types is quite telling about western attitudes: they are mostly servants and/or buffoons. ..

The use of Africans in advertising {in Europe was not always negative, and if we look before the American settlement of the New World to the } middle ages, the black *Moor* was a popular emblem of brewers and inns, as well as of the tailors' guild. This derived from the popularity of the African King, Balthasar, the youngest and most dashing of the three Wise Men who came to worship the Christ child, one of whom had become black in paintings from the 14th century. Since the middle ages, druggists in western Europe also used a semi-black turbaned head as signpost, indicating the southerly origin of their dried medicinal herbs...

Just as depiction of Africans in nature and with animals were a pictorial tradition which reflected a conceptual framework, the same holds for depiction of Africans in the western world with fruits and animals. Thus the American cliche of Africans and watermelons is an adjunct to the child/ savage ideology and hints at several codes: laziness, lack of self-control, etc....

{Our image analysis showed} how deeply embedded in western culture prejudices of non-western cultures are, how deep their foundation is in experience and feeling. African non-western people are routinely associated with behavior that is deviant and disapproved. Classic quotes: 'Poor Topsy, why need you steal?' And Mary Poppins to Michael: 'I understand that you're behaving like a Hottentot.'

... Domination, whether in the form of slavery, colonialism or ethnic status hierarchy, also means a sexual gain for European males. In images of blacks, this gain is reflected in denigrating caricatures of black males ...{All this} played a part in the social suppression of black virility. The suppression of black masculinity relates to the marginalization of black males in the labor market, to black unemployment, and thus to the ghetto syndrome.

Are contemporary images of blacks and Africa in western popular culture simply more of the same?79

The extent to which the subliminal influences of negative European race imaging are still potent today can be seen in Salman Rushdie's *Satanic Verses*. Not only does Rushdie reject his own Muslim culture, but, as suggested by the renowned Professor Ali A. Mazrui in his book titled *The Satanic Verses, or a Satanic Novel?* Rushdie may also have adopted the notion that any African resistance to English concepts was a fight against civilization, against history. It is said that when we open the window for fresh air, we often let in the flies as well. When Rushdie studied at Cambridge, did anti-Muslim and negrophobic attitudes enter in along with his English education? Prof. Mazrui seems to think so when he writes:

If Hitler hurt the Jews, and Rushdie hurt the Muslims, did both dislike the Blacks as well? There is no doubt about Hitler's Negrophobia. But are there elements of Negrophobia in Salman Rushdie's *Satanic Verses* as well?
... Rudyard Kipling portrayed the African colonial as "half devil, half child." For a long time, Muhammad was regarded as full devil. The {Europeans} later had a name of scorn for the African. The name was "nigger". The Europeans in medieval times also had a scornful name for the Prophet of Islam -- the word was "Mahound."
Rushdie claims that just as "Blacks all chose to wear with pride the names they were given in scorn {speaking of men like Martin Luther King, Jr., whose name is that of a well-known German Protestant reformer}; likewise, our mountainclimbing, prophet-motivated solitary is to be the medieval baby-frightener, the Devil's synonym: Mahound." Rushdie adds:

That's him. Mahound the businessman, climbing his hot mountain in the Hijaz. The mirage of a city shines below him in the sun. (p. 93)

Rushdie also turns his torchlight on Bilal -- the first African Muslim in history. Rushdie reminds us that the Prophet had seen Bilal being punished for believing in one God. It was like Kunta Kinte being whipped to give up his African name, Toby versus Kunta Kinte.
Bilal was asked outside the pagan Temple of Lat to enumerate the gods. "One," he answered in that huge musical voice. *Blasphemy, punishable by death.* They stretched him out in the fairground with a boulder on his chest. How many did you say? "One," he repeated, "one." A second boulder was added to the first. One on one. Mahound paid his owner a larger price and set him free.

Bilal became the first great voice of Islam. The beginning of an African vocal tradition in world history -- from Bilal to Paul Robeson and beyond. Black Vocal Power in World History began with Bilal... Rushdie does not give either Bilal or Islam the explicit credit of being a multi-racial religion from so early a stage. Bilal set the grand precedent of Islamic multi-racialism -- fourteen centuries *before* President Jimmy Carter tried to persuade his own church n Georgia to go multi-racial. Rushdie cannot resist certain epithets against the African, Bilal. Rushdie makes a character think of the African, Bilal, as

> scum... the slave Bilal, the one Mahound freed, an enormous black monster, this one, with a voice to match his size. (p. 101)

Baal, in the novel, is the poet and satirist. Probably Rushdie sees himself in the character Ball (not to be confused with *Bilal!*) And what does the poet Baal say to the Black man Bilal? "If Mahound's ideas were worth anything, do you think they'd be popular with trash like you?" (p. 104) Bilal reacts but the Persian Salman restrains him. Salman says to the Black man, "We should be honored that the mighty Baal has chosen to attack us." He smiles, and Bilal relaxes, subsides (p. 104).

Rushdie gives Bilal a reincarnation as a Black American convert to Islam. This time Bilal is called *Bilal X* -- like Malcolm X. Bilal X seems to follow the leadership of a Shi-ite Imam in rebellion against a reincarnation of the Prophet's wife Ayesha -- this time Empress Ayesha. Bilal X has the same old vocal power of the original Bilal. Under the influence of the Imam the Black American not only wants to rewrite history. He has been taught to rebel against history -- to regard it as "the intoxicant, the creation and possession of the Devil,l of the great Shaitan, the greatest of the lies -- progress, science, right..."

The Black American's beautiful voice is mobilized against history. Bilal X declaims to the listening night (on the radio):

> We will unmake history, and when it is unravelled, we will see Paradise standing there, in all its glory and light.(p. 210.)

The Imam has taught the Black American that "history is a deviation from the path, knowledge is a delusion..." Rushdie tells us: "The Imam chose Bilal for this {propaganda} task on account of the beauty of his voice... the voice of American confidence, a weapon of the West turned against its makers, whose might upholds the Empress and her tyranny." When Bilal X, the Black American, protested at such a description of his voice, and insisted it was unjust to equate him with Yankee imperialism, Rushdie puts the following words in the mouth of the Imam:

Bilal, your suffering is ours as well. But to be raised in the
house of power is to learn its ways, to soak them up, through
that very skin that is the cause of your oppression. The habit
of power, its timbre, its posture, its way of being with others.
It is a disease, Bilal, infecting all who come too near it. If the
powerful trample over you, you are infected by the soles of
their feet. (p. 210)

Is Rushdie making fun of African Americans generally? Or is he
satirizing Afro-American *Muslims?* Or is he ridiculing the significance of
Malcolm X? But since many Afro-American Muslims regard Islam as one
route back towards re-Africanization, and therefore a point of return to
Roots, is Salmon Rushdie simply continuing his basic contempt for his own
roots?[80]

However most of European philosophy and history did not
concern Africans and non-Europeans, and thus the tenuousness of
American efforts to hold on to these finer liberal democratic notions
of freedom, etc. of British civilization led paradoxically to a greater
enforcement of its value against vastly culturally different national
minorities:

From the winning of independence to the late Jacksonian period, white
Americans invoked a negative image of Indians to assuage their own inse-
curities about their culture. Constantly taunted by Europeans for their lack
of art, literature and refinement, Americans found solace in contrasting their
culture to that of the original inhabitants of the New World forests. When
held up to the Indian tribes rather than the European nations, the United
States appeared to be on the high road to advanced civilization... Since the
territorial expansion of the United States had become synonymous with the
advancement of civilization -- and since Americans had increasingly tended
to attribute their democratic institutions {an area in which they felt advanced
in relation to the Europeans, despite their engagement in dispossession and
genocide *vis-à-vis* the Native Americans, and slavery *vis-à-vis* Africans},
mobility and much of their unique culture to the existence of a vast frontier --
the Indians and Mexicans were bound to suffer... they regarded nonwhites
who held desirable land as obstacles to progress rather than worthy benefi-
ciaries of humane assistance...[81]

In short, there were many western philosophical traditions
available: those that would not support the U.S. anti-social contract,
and those that would. The Anglo-American scholars chose those
that would. The selected philosophic traditions were promoted, and

became the framework for much of the U.S. educational system. As Allen Bloom noted in *The Closing of the American Mind:*

> Every educational system has a moral goal that it tries to attain and that informs its curriculum. It wants to produce a certain kind of human being. This intention is more or less explicit, more or less a result of reflection; but even the neutral subjects, like reading and writing and arithmetic, take their place in a vision of the educated person. In some nations the goal was the pious person, in others the warlike, in others the industrious. Always important is the political regime, which needs citizens who are in accord with its fundamental principle. Aristocracies want gentlemen, oligarchies men who respect and pursue money, and democracies lovers of equality.[82] {And it follows that U.S. white nationalists want and need racists}.

This understanding is important because it reminds us that there are good and bad -- all types of people etc., -- in all races or nations. Those that chose to come to the U.S. did not represent a race, but more importantly a type of attitude, and to meet their economic and political needs, they chose a few particular types of philosophies suited to those needs from among the many available to them.

American Christianity

Laboring under the politico-economic necessity of oppressing and/or ignoring the existence of its minorities, the U.S. formed a popular interpretation of Christianity which served the spiritual needs of the anti-social contract and provided another element in ensuring its existence. The following description gives the scheme of things which was generally accepted, with minor variations, by practically all Anglo-Americans who called themselves Christians:

> Before time began, there existed one Eternal Being, perfect in every way and beyond the power of human thought to comprehend. .. he was also, in a mysterious way, three persons in one God, the Glorious and Blessed Trinity of Father, Son and Holy Ghost. He needed nothing beyond himself, but as an act of divine will or love, He began the process of creation by which other beings such as man, nature, the angels, etc. were brought into existence.
> One of his creations, the Angel named Lucifer or Satan, in spite of the impossibility of success, revolted. His inordinate pride in his own splendor drove him to lead a revolt against God. Several million angels rallied to his cause, but the inevitable happened: they were defeated and banished from heaven, the abode of God, to a domain of their own, a place of torment called Hell...

Man was the last created being, made by God in his likeness. He, like the animals, was created in sexes: the first man was called Adam and the first woman was called Eve. God set them in a garden where they lived in bliss. There was, however, one significant qualification. In the garden were two symbolic trees, the tree of everlasting life, and the tree of knowledge of good and evil. The fruit of these trees was prohibited to them. Satan, pursuing his feud against God, approached Eve in the guise of a snake, and urged her to eat the fruit of the tree of knowledge of good and evil...So occurred the first of the long series of human acts of disobedience to God, the technical name for which is sin. The sin of Adam and Eve was the original sin. Sin brings punishment. God condemned man to work for his living all his days *{was the slave labor imposed upon the enslaved Africans viewed in American Christian methodology as God's punishment for unredeemed sin or nonacceptance of Christ?}* ...

But God could not permit this temporary triumph of Satan to continue unchallenged. Though his justice made it necessary that man be punished, yet his love required that he find a way to bring man back to the bliss he had forfeited. In traditional terminology, God looked for a way to redeem man...

God's plan of redemption called for the coming upon the earth of a Saviour. *This Saviour would in fact be the Second Person of the Holy Trinity, the Son, taking human flesh from the stock of a chosen race, the Hebrews, singled out from among the peoples of the earth.* {italics added} Then at the predetermined time, the Saviour came. *A virgin of the chosen race was impregnated by the Third Person of the Holy Trinity, the Holy Ghost, and of this union, the Saviour both God and Man was born.*

Did the Judaic notion of a chosen people play a role in justifying the concept of racial superiority? Did the Anglo-American Christians, with no typically semitic physiognomies, but rather looking like blond, blue-eyed Europeans, somewhere in this mysterious process decide consciously or unconsciously that they were the chosen people? American evangelism and tele-evangelism concentrate the bulk of their message on arcane descriptions of the battles of the Old Testament, on the Pauline formulation of original sin, and on the Book of Revelations. Little time is devoted to the life of Jesus (PBUH) (unlike present-day Liberation theology in Latin American, which finds the basis for its imitation of Christ in identification with and support for the struggles of the poor and oppressed. Indeed, the concentration on Old Testament history, with its assertion of the Hebrews as the Chosen Race, may well have some linkage with contemporary financial support by Zionists for Christian fundamentalist groups such as the Moral Majority, in solicitation of their support in turn for the presumably Biblically ordained State of Israel.

It is Christ the Saviour who redeems man from his predicament by making a supreme sacrifice. The original sin of man was an infinite offence: infinite because it was a direct affront to the infinite majesty of God {a notion of collective, inheritable guilt,}. Man could make no infinite restitution for this, which would be the only way of restoring the situation. But what man could not do, another could do on his behalf...

The job of the Redeemer, Christ, was to "pay the price of sin." This he did by submitting to death at the hands of men who were the agents of Satan. Once he, an infinite and sinless Being, had suffered death as the penalty for sin, the debt was paid, God's justice was vindicated, and his love could prevail...

Then, on the third day, He rose again triumphantly to life on earth...

The end of the story is yet to come. There will dawn a day when God, who began the physical universe which we know, will bring it to an end. Christ, who according to some versions of the story was His Agent in the creation, will be His Agent in its destruction.[83]

Alongside its belief, the philosophic orientation of American Christianity, like Hobbes and Locke, always laid a heavy emphasis on law and order. To some extent it inherited this from Jewish thought. In the Jewish scriptures, which American Christians emphasized heavily in their teachings, there is frequent reference to a contract or covenant to obey God's law. God in turn contracts to be their protector and send them prosperity.

However, American Christianity gives a different emphasis to the idea of law. There was a widespread, though by no means complete, revolt against the Jewish interpretation of Divine Law as regulating conduct. *Instead, there arose an insistence that God had commanded not so much what you should do as what you should believe. Belief, not conduct, was to be prescribed by Divine Law. Just as under the older system, God was thought to have prescribed penalties for those who didn't act rightly, He was now thought to have prescribed penalties for those who didn't think rightly. Of course, this left the American Christians, like the South Africans, free to pursue the economic benefits of African enslavement while receiving God's full blessing for believing in Christ.*

The importance of this summary of the Anglo-American Christian orientation is to highlight the ramifications of the orientation of this great world religion to Anglo-American Christian thought throughout the history of their contact with African and Native Americans. (The evolution of the Anglo-American Christian orientation does not in any way mediate the Greek and Roman philosophic influence, but instead

we suggest, Greek, Roman and European philosophies and images helped to determine the Anglo-American Christian orientation.)

1. Did Christian belief in a chosen people serve to justify the Anglo-American belief in their racial superiority over Africans, etc'?

It is not difficult to understand why the Hebrews felt that God had chosen them, and that he was made in their image; after all, this was the common orientation of all peoples during their tribal and primitive stages of development. God was always thought to be in their image and favorable to them. This notion of a chosen people remained potent in American Christianity, and through some sleight of hand, they identified it with themselves, in their civilizing mission towards the national minorities. The obvious implication of accepting the concept of a chosen race is that all other races are *not* chosen by God. The non-chosen should do the hard work, therefore, in order that the chosen might live in bliss and develop advanced ideas and Godly culture for all. One might further extrapolate that the not-chosen must seek their redemption through the chosen, or by following in the path of the chosen; the chosen represent the ideal to be emulated, indeed, to become, if such were possible. Was it because of such an American orientation that the right of other minorities, European or non-European, to be both culturally different and equal appeared to it to be mutually exclusive?

2. Did the historical exclusivism and doctrinal rigidity of Christianity facilitate the early American orientation?

As Doctrine and the absolute submission to belief in it was of central importance to American Christianity, rather than simpler tenets advocated by Jesus, so too an awareness of and belief in the Crucifixion/Redemption message became essential to salvation. Good works, a life of virtue, were not enough. As Dante had condemned the virtuous Greeks to Hell, and the Prophet Muhammad to its innermost circle, so too American Christians believed that whole civilizations who had never heard of Christ were doomed, as were those unlucky enough to have lived before his coming. In the belief that the fate of souls hung on receipt of the (correct, Pauline) Christian message, Christian missionaries set out to save the luckless colored races the world over. American Protestantism increased this exclusivism, insofar as, in a vulgarization of the basic tenets of faith and grace fundamental to Protestantism, good works no longer received even the value or respect accorded by Catholicism, and belief was all. Necessarily, then, the belief systems of other cultures,

such as the Native Americans, enslaved Africans and other minorities were not only foreign but pernicious, and if Christian, but without Anglo-American orientation, not exactly correct practice. If souls depended on belief in Christ's Crucifixion/Redemption as the key to the hereafter, who would deny that forcing Christianity on non-Christians was not to their benefit?

In short, this collective psychological construct created a situation wherein Anglo-Americans were able to do almost anything under their political apparatus, and still feel that they submitted to Divine Law simply because they believed in it. (The separation of Church and State, of belief and actions, in this instance serves to separate moral consciousness from the moral repercussions of immoral behavior, and thus facilitated such behavior. This orientation to or interpretation of Christianity suited the buccaneering spirit of those who left their homes and friends in Europe to seek riches in the new world.}

The Anglo-American orientation to Christianity served not only as a system of belief, but also as a psychological screen whereby acts of the most primitive brutality might take place and effectively be ignored, repressed and transformed. Thus we need not be surprised to find the earlier U.S. settlers claiming to be the most devout Christians at the same time that they waged a brutal war of extermination against the Native Americans, and imported, enslaved and murdered thousands of Africans.

The Christianization of the national minorities came to mean more, however, than their simple acceptance of the Christian faith and dogma. It also required a complete acculturation to elements not central to the true Christian faith -- ie. to the Anglo-Saxonized American culture, as it was in the process of developing.

Protestant missionaries often initiated the most determined assaults upon Native American culture, but their assumptions of superiority were shared by government leaders and the general {white} population as well...Not only should Indians accept {Anglo-American} Christianity; they should also accept the English language, the white man's {Anglo-American} government, his approach to the natural environment, and his social and cultural mores. Missionaries, in short, tried to make Indian men and women {believe that they should be} farmers, artisans and homemakers, mirror images of the supposedly more advanced whites {Anglo-Americans}. [84]

3. The Nationalization of Christianity: The Religion of Americanism?

What happened in America, however, was a re-wedding to a significant degree of Church to State, in the sense that the national religion (filling the cultural needs of the melting pots) became a

religion of Christianity mixed with patriotism and white nationalism, and indeed, became the religion of Americanism.

The authoritarian, Christian, middle-class morality with strict social norms or sanctions, espoused by the controlling political and business elites, met little effective challenge before the late 1880s. An intense religiosity, particularly among the educated upper-middle class, spilled over into business and the professions. Getting ahead with one's own work and duty to God were easily confused...In colonial times it sufficed for the commercial elite of New England to see their province as God's example to Europe and the Americas, the city upon a hill. By the end of the nineteenth century the sense of mission had expanded to spreading His kingdom, as only Anglo-Saxons {Anglo-Americans} could, to all the rest of the world.[85]

In America, the Bible was not interpreted through great national interpreters, as it was elsewhere in Europe, but rather

approached directly in the manner of early Protestantism, every man his own interpreter. The Bible was thus a mirror of that indifference to national cultures inherent in the American method. Most students also participated in a remarkably unified and explicit political tradition that possesses one writing known to everyone and probably believed by most, the Declaration of Independence. [86]

Describing Progressive Patriotic Protestantism as the national religion of America, with those three words encapsulating the core of its values, Henry F. May observes the following:

One must quickly admit that Progressive Patriotic Protestantism was never the religion of the whole people. It was, however, the vision of the crucial and dominant Northern middle class, a group which often forgot that it was *not* the whole people. It was the religion of those who dominated the biggest and richest churches, the national religious press, the interlocking reform movements, the colleges, the national magazines, and to some extent the politics of the nation. [87]

Godliness and economic prosperity were tied to one another, each justifying the other, and of course, the reverse applied to the poor and destitute, and oppressed minorities:

In somewhat degenerate form, Calvinist doctrine helped to form the intellect of most of the American elite, since it was taught at most of the colleges. Here it was combined with laissez-faire economics to show the necessity of poverty and the depravity of the lower classes. [88]

The preaching of religion in America, then, reflected its close alignment with the ruling elite, and that elite's needs and values, rather than with the masses of ordinary poor people or minorities:

The most effective preachers of the national faith in this period, however, were not ministers, but statesmen. Almost every major leader sounded its note.[89]

In the hands of statesmen from Theodore Roosevelt to Ronald Reagan, the national faith became the national hypocrisy, as Presidents and those running for office on every level paid self-serving lip service to and re-enforced American Christian values. Although Christianity, during its history in Europe, tended to be conservative, and to represent and defend the needs and ideals of powerful Church and State interests, in America, it became resolutely associated with capitalist economics, white nationalism, the so-called American way of life, and right-wing American defense and imperial policies. Accordingly, the acceptance of God became linked to the acceptance of the American political system, and those who questioned the latter were threatened with all the penalties available to the former.

Historical Judicial Biases

In the U.S. perhaps more than in most other countries, the law is projected as absolutely objective and unrelated to power or the desires and priorities of the ruling elites. However, on closer examination, we will find that the U.S. judicial system operates historically to favor the maintenance of the status quo, of wch white nationalism is an integral part. A brief evidence that the U.S. judicial system historically tends to follow the objectives of those in power rather than an abstract objectivity can be seen by examining the contradictions in the legal decisions concerning the African-American minority listed below. A closer examination of the decisions in conjunction with the political activity of the minority at the time that the decision was made suggests that the U.S. Supreme Court always did the minimum required for the minorities to meet the necessity of political crises created by undeniable demands from the minorities[90] and whenever such undeniable demands were not present from the minority or the minority coupled with the international system, the Supreme Court generally ruled against their interest, or for the maintenance of the status quo.

LEGAL SUMMARY OF THE PERIOD (1897-1960)
BY REFERENCE TO THE IMPORTANT COURT CASES
CONCERNING THE CHIEF U.S. MINORITY

The Period of Slavery

1) 1806 *"Negro London" case*: Chief Justice John Marshall wrote excessively technical opinion turning down slave's bid for freedom.

2) 1810 *Scott v. Negro Ben*; enslaved Africans freedom suit turned down.

3) 1816 *Negress Sally v. Bull;* enslaved Africans freedom suit rebuffed.

4) 1827 *Williamson v. Daniel;* mulatto children of African mothers and Anglo masters declared slaves.

Beginning Civil War Period

5)1857 *Dred Scott v. Sandford*; Chief Justice Roger B. Tancy declared no African citizens could be protected by the federal government

6) 1863 Thirteenth Amendment freed Africans and descendents.

Beginning the Reconstruction Period

7) 1866 First Civil Rights Bill declared the Africans in the U.S. to be citizens.

8) 1868 Fourteenth Amendment declared Africans in the U.S. to be citizens.

9) 1870 Fifteenth Amendment banned vote discrimination.

Beginning of the End of Reconstruction

10) 1873 *Slaughterhouse Case*; Court began restricting amendments by holding that civil rights remained under state than federal government protection.

11)1975 Civil Rights Bill enacted by Congress gave African-American right to equal treatment in places of public accommodation.

 United States v. CruIkshank; outted congressional statute designed to curb violence against African-Americans.

 United States v. Reese; held 15th Amendment "did not confer the right of suffrage on anyone" and that all it did was prohibit denial of vote on account of race or color.

12) 1879 *Strauder v. Virgnia v. Reeves*

 1- regarded the 1875 Civil Rights Law as giving an African American defendant a right to indictment and trial by juries

> chosen from panel on which African-Americans had not
> been excluded because of race;
> 2 - a defendant must pursue his remedies in state courts in the
> absence of an exclusionary statute but with a final report to
> the Supreme Court;
> 3 - the African-American defendant must assume the burden
> of proving racial discrimination where there was an absence
> of African-Americans from jury panels;
> 4 - the action of a state official in arbitrarily excluding African-
> Americans from jury panels was state action.

13) 1883 *United States v. Harris*;
> 1 - In effect this decision said government could not protect an
> African- American citizen against mob violence;
> 2 - declared Civil Rights Act of 1875 unconstitutional. Justice
> John Marshall Harlan dissented, arguing that the substance
> and spirit of the 14th Amendment had been "sacrificed by a
> subtle and ingenious verbal criticism". At this point the
> reconstruction acts have been for all practical purposes
> legally dismantled.

Beginning Period of Apartheid

14)1890 *Williams v. Mississippi*; agreed with a Mississippi Court that
the state had "swept the circle of expedients" to disenfranchise Afri-
can-Americans, but refused to intervene.

15) 1896 *Plessy v. Ferguson*; upheld separate-but-equal doctrine.
Justice Harlan dissented, declaring: "Our Constitution is color blind".

16) 1903 *Giles v. Harris*; upheld clauses in Alabama Constitution
which disenfranchised African- Americans.

17) 1905 *Hodges v. United States*; reversed the conviction of
members of a mob that drove African-American workmen off an
Arkansas job. Justice Harlan dissented.

18) 1908 *Berea College v. United States*; upheld a Kentucky
Court's conviction of Berea College for violating a state law forbidding
instruction of African-American and Anglo-American students
together in a private school.

19) 1917 *Buchanan v. Warley;* struck down a Louisville, Kentucky,
ordinance requiring Anglo-Americans and African-Americans to live in
separate blocks.

20)1923 *Moore v. Dempsey;* ordered retrial for 42 Arkansas
African-Americans speedily convicted after a minority violence started
by Anglo-Americans.

21)1927 *Nixon v. Herndon*; struck down Texas Law barring African-Americans form voting in Anglo-American primaries.

22)1932 *Nixon v. Condon*; overruled a Texas Law giving the executive committee of the Democratic Party the right to determine who could or could not vote in primary election.

Powell v. Alabama; reversed Alabama Supreme Court which upheld death sentencing of eight African-American " Scottsboro" boys. Ruled the men had not been adequately represented by counsel and had not received an opportunity to defend themselves.

23) 1935 *Grovey v. Townsend*; upheld Texas Democratic Party when its convention excluded African-Americans from primary elections.

Norris v. Alabama and *Patterson v. Alabama;* reversed retrial conviction of "Scottsboro Boys" because of the systematic exclusion of African- Americans from the indicting grand jury panel.

24) 1938 *Missouri v. Gaines*; ruled the state must provide equal educational facilities for African- Americans within its boundaries.

25) 1940 *Mitchell v. United States*; in effect ruled railroads must exercise great, or greater, care to see to it that every accommodation provided for Anglo-Americans was also afforded African-American passengers.

26) 1944 *Smith v. Allwright*; unanimously overruled Court's 1935 ruling in *Groves v. Townsend* that a political party could exclude African- Americans from a primary election.

27) 1948 *Sipuel v. University of Oklahoma*; held that state must provide legal education for African- Americans " as soon as it provides for" Anglo-Americans.

28) 1952 *Sweat v. Painters*; held that a separate law school for African-Americans was not equal and could not be made equal to a state institution.

End of Apartheid

29) 1954 *Brown v. Board of Education*; ruled segregation in public schools unconstitutional.

When we compare the decisions in cases 13, 14, 15, 16, 176, 18, 24, 26, 27 and 29 with the other case decisions highlighted during this period of apartheid, we readily see the legal contradictions. We can immediately realize the necessity of consulting the political needs of the majority interest in relation to its minorities in

order to secure a clearer understanding of minority rights law in the U.S..[91]

While each Southern state passed its own Black Codes, the following represent common points in Southern Black Codes (not included in the Constitution but an original part of the anti-social contract) which were allowed to stand until challenged by the minority:

- African-Americans caught without visible means of support were liable to indenture to an employer. Those caught attempting to escape this service were subject to imprisonment;

- African- American orphans were bound to Anglo-Americans to work out their childhood;

- Curfew forced African-Americans off the streets at sundown;

- African-Americans could not testify in law courts against Anglo-Americans regarding abuses or shortages in wages;

- African-Americans migrating to some states had to post bonds regarding their travels, or be subject to arrests as vagrants.[92]

The U.S. judiciary followed a concept of accepting minority oppression and inequality depending on the ability of the minority to make a successful legal challenge. Given the socio-economic and political position of the minorities, this of course favors the requirements of white nationalism, and thus is another unwritten tenet of the U.S. anti-social contract.

Historical Congressional Acceptance of Inequality

Congressional bias in favor of the maintenance of the U.S. status quo in relation to the unequal status of U.S. minorities is a very important element of the anti-social contract. It can historically be seen in the inactio nof Congress in relation to minority inequality when there is no crisis, and it is evidenced by occasional anti-minority legislation passed by Congress. Whether we examine the Walter McCarran Immigration Act and the debate surrounding it, or the historical debate surrounding the Civil Rights Acts and states rights, etc., we see evidence of Congressional bias favoring white nationalism, and the anti-social contract of which it is an element.

A recent indication of historical Congressional bias favoring the maintenance of the status quo, of white white nationalism forms an integral part, the case which this book highlights, was Congressional unwillingness to ratify the major international human rights treaties until 1988, although these United Nations Treaties (which are

concerned, among other things, with the problems of minority oppression) were first signed by the U.S. President in 1950 and were ratified by the Soviet Union and most of the western democracies as early as the middle 1960's. Even when one was ratified in 1988 (the Convention against the Crime of Genocide), the ratification included so many reservations and understandings as to render the treaty totally subservient to the limits of the legal principles and concepts already available in the U.S. Constitution and, through constitutional omission, to the U.S. anti-social contract. Instead of the Congress seizing the opportunity to explain the interpretation of the U.S. Constitution so as to undo the anti-social contract, it opted to limit the import of the treaty.

Ratification of this treaty in 1988 took place only after great embarrassment to U.S. human rights foreign policy, because the U.S. was the only western democracy advocating human rights which had not ratified any of the major human rights treaties, particularly the Genocide Convention. In 1988, ratification did occur, but as before stated, only with reservations designed to make it impossible for international U.N. interpretation of these treaties to be legally accessible to U.S. citizens through the rule of constitutional law. The result was to put the situation in limbo, in order that the minorities might be adequately discouraged from attempting to seek the protection of their rights in international law.

When we examine these treaties, we find that the international legal rights of minorities would likely appeal to minority groups seeking equal status, quotas etc. and those not desirous of forced assimilation, , all of which represent a challenge to white nationalism. We contend that the awareness of their possible usefulness to U.S. minorities was one significant factor acting to cause Senate reluctance to ratify the treaties in the first place and was a major factor necessitating the reservations with ratification. Some evidence can be seen in the facts that: the same southern-conservative coalition forces of opposition which attempted to counter the 1824 Anti-Slavery Treaty, 1868 Reconstruction Acts; and the Civil Rights Acts of 1958, 1964, and 1968, was arraigned against passage of the human rights treaties;[93] that all non-minority related objections raised against ratification were convincingly shown by the testimony of expert witnesses at Senate hearings to be without substance, that although the minority problem is often mentioned as a factor, the response of those supporting ratifications (in keeping with the unspoken nature of the anti-social contract) ignored this question;

and that although the U.S. has signed other types of treaties affecting domestic law, it is only the human rights treaties that the U.S. Senate raised to the level of a political issue, and attempted to block in total.[94]

In an internationally diplomatically sensitive pattern reminiscent of the difficult passage of the Civil Rights Act of 1964, we found ratification of the major human rights treaties being pushed by the executive,[95] judiciary and independent liberal elements of the U.S. which realized that the U.S. international image was being damaged by non-ratification. To limit damage internationally, such elements (including the Presidents of the U.S.) quickly signed or gave verbal support to the human rights treaties, knowing full well that they would not easily be ratified by the Senate. The treaties became stalled in a Senate committee under the control of a southern conservative.[96] The International Bill of Rights and a series of other human rights treaties have yet to reach the Senate floor.

Due to the exceptional power given by the U.S. system to Committee chairmen in the Senate and Congress, and the crucial role played by committees in preventing legislation from reaching the floor, [97] a majority of senators in favor of this legislation would be extremely reluctant, in the absence of a clear crisis situation such as that preceding the passing of the Civil Rights Acts of 1964 and 1968, to attempt to rally the support necessary to override the Committee and call for the treaties to be reported.

Yet, in view of the fact that, between 1973 and 1977, representatives of numerous groups with a claimed total combined membership of approximately 100 million people urged ratification, Senate prolonged recalcitrance underlines the extent to which the Senate viewed the treaties against forced assimilation and supporting pluralistic societal objectives (e.g. recognition of minority traditions, culture and collective rights as sharing in the definition of what is America) as contradictory to unstated, unwritten and unspoken American interest,[98] i.e. to the anti-social contract. America wants to be seen as an "open society offering freedom of choice and growth and well-being to all its citizens regardless of race, creed, color or national origin...."[99] -- but it intends that this be accomplished through cultural assimilation and Anglo-Saxonization.[100]

Given the contradictions between the anti-social contract and minority rights in International Law, the ratification of the treaties without reservation would represent the possibility of a great systemic

alteration in U.S. minority rights and status. We can only suggest that the Senate is aware of the U.S. anti-social contract and that this is a significant factor prompting the Senate to react negatively or with severe reservation to the human rights treaties.

The awareness of the treaties' potential international and domestic ramifications was in evidence among non-governmental opponents and proponents, among whom the issue of ratification seems to strike a far deeper vein of passion than would the passage of the average legislative act. As a statement regarding the Genocide Convention issued by the Office of Legal Adviser, Department of State, 22 March 1977, noted:

Indeed , there is a note of fear behind most arguments (against ratification)...as if genocide were rampant in the United States and this nation could not afford to have its actions examined by international organs, as if our Supreme Court would lose its collective mind and make of the treaty something it is not, as if we as a people don't trust ourselves and our society. The rhetoric of the opponents, and to a degree the proponents, has obscured what a modest step the convention represents. Philosophical, moral, and constitutional questions have been raised which go far beyond this modest step and probe man's relationship to his fellow man.. 101

Also the following excerpts from testimony given by opponents and proponents of the treaties at congressional hearings abound with references to the U.S. civil rights and minority problem. In essence these proponents are questioning whether the legal supports for the anti-social contract can be maintained if the human rights treaties are ratified.

Miss Maud-Ellen Zimmerman, Chairman, Voters Interest League, states in her opposing testimony:

Could not a citizen charge his own government with genocide and request a hearing before an international tribunal? *Time Magazine*, in its issue of December 12, 1969, reported the intention of the Black Panthers to "go before the United Nations and charge the United States with genocide against the Panthers." A similar charge of genocide committed by the government of the United States "against the Negro people of the United States" was placed before the United Nations by a petition said to be supported by Paul Robeson, Mrs. Coretta Scott King, the Reverend Ralph D. Abernathy and others. The petition was published in 1970 in the book *We Charge Genocide*, of which a copy was filed with this Committee in 1971 by ARA Delegate Deutsch. (Committee hearing March 10, 1971, pp. 31-32.)

Would not the "permanent impairment of mental facilities" as the meaning of "mental harm" in Article II (b) still make U.S. citizens open to the charge of genocide in view of the U.S. Supreme Court opinion in *Brown v. Board of Education* that separation of Negro children, quote: "From others of similar age and qualifications solely because of their race, generates a feeling of inferiority as to their status in the community that may affect their hearts and minds in a way unlikely ever to be undone... and has a tendency to (retard their) education and mental development...[102]

Note that Miss Zimmerman was not concerned with the horrible effects on minority children; she was concerned exclusively with making it clear that ratification may make it possible for minorities to present their problem for international remedy.

Mr. E. F. W. Widermuth, of the Queens County Bar Association, while calling attention to what is perhaps the most standard reason given for not wanting to sign the human rights treaties -- the compromising of U.S. sovereignty, referred pejoratively to the historic tendency of the Supreme Court to override the legislative branch of government. During the hearing, this reason was so often effectively refuted, one can only imagine that its continued use by opponents reflected their emotional commitment against the treaties for quite different reasons, which they preferred to leave unspoken. In his article, "Shall the U.S. of America Surrender to the World Court?", which was entered in the Congressional Records, Widermuth states:

We have witnessed our own lifetime-appointed Supreme Court exercise absolute and unrestrained power; nullify acts of Congress, usurp legislative powers and apply its legislation to past transactions, not to mention its having decreed itself to be the supreme law of the land, the Constitution of the United States to the contrary notwithstanding, all with absolute impunity...[103]

On occasion, U.S. extreme rightists, not respecting the need for subtlety, lapsed into an expression of fear of all traditional anti-social bugaboos in their opposing testimony: non-Christians, non-protestants, Jews, African-Americans, liberals and communists. During the May 26, 1977 Senate Hearing before the Sub-Committee of the Committee on Foreign Relations (U.S. Document 41-544), Stanley Rittenhouse, Legislative Aide of the Liberty Lobby, stated:

The ugly head of anti-Christianity is rising more and more in the last few years. This treaty would continue that trend. Our founding fathers

incorporated Christian principles in our U.S. Constitution. Because of this, a maximum of human rights {for the white ethny} have been brought into play, resulting in an economic prosperity {for the white ethny} unknown before. *Had the Genocide Convention been in effect from the beginning of this nation, all the missionaries of the past would have been guilty of Article II, and I quote: "In the present convention, genocide means any of the following acts committed with intent to destroy in whole or in part, a national, ethnical, racial, or religious group."* {italics added} Keep in mind that this excludes political groups.

When pursued to its logical conclusion, and the liberals around the world would do just that, it becomes ridiculous. In the case of cannibals {as mentioned earlier in the image analysis by Jan Pieteric, "cannibal" is a symbol in white culture for blacks}, it would not be genocide if one member of the tribe devoured another; but it would be genocide when a Christian missionary tries to civilize the savage and convert him to Christ. It is genocide when the white objects to black demonstrations in South Africa, but not genocide when Uganda's Idi Amin systematically kills off and eats the liver of his rivals, as was reported in the paper.

Another case in point is the Jewish community. Since many of those within the Jewish and Zionist community hate Christianity and Christians, and since many of these consider as "traitors" Hebrews who recognize Christ to be the Messiah, any Christian who attempts to convert a Jew would be guilty of genocide under this treaty...

Remember that the Communist nations ratified the Convention after it omitted political grounds, but with a reservation "against jurisdiction of the International Court of Justice over disputes under the Convention."

However, it is to the statement of Bruno V. Bitker, former Chairman, Committee on International Human Rights of the American Bar Association, that we turn for expression of points which we have earlier underscored, namely:

1. that all legal objections posed by the Senators were successfully answered;

2. that important domestic political reasons for non-ratification are admitted not to have been advanced (in particular, the question of minority oppression)

3. that the traditional southern civil rights techniques, e.g., the filibuster, have been used in the Senate to prevent ratification;[104]

4. that international pressure is a major cause for liberal and executive governmental support for ratification;

5. that a lack of a crisis situation has permitted what appears to be a determined minority to block ratification of the major human rights conventions.

THE ANTI-SOCIAL CONTRACT

We suggest that the only reason important enough to block Senate ratification without reservation over the past decade is the issue of minority oppression as prescribed in the U.S. anti-social contract. We draw the reader's attention to the bold-face typed lines in the Bitker statement:

As noted in the Committee's last report, no fewer than 82 members of the United Nations (perhaps 83 depending on how China's accession is viewed) have become parties to the Convention. Although the United States was a leader in drafting and securing its adoption in the United Nations in 1948, it is the outstanding laggard in ratifying it. Its failure to ratify borders on constituting a national disgrace. As the late Chief Justice Earl Warren said in December, 1968, "We as a nation should have been the first to ratify the Genocide Convention... Instead we may well be the last..."

Since the Committee's 1976 report, a new President of the United States has come into office. President Carter has followed all of his predecessors from Truman through Eisenhower, Kennedy, Johnson, Nixon and Ford in support of America's furthering the cause of international human rights, including ratifying the Genocide Convention. As President Carter stated on March 17th to the United Nations; "Ours is a commitment, and not just a political posture. To demonstrate this commitment..., I will work closely with our own Congress in seeking to support ratification..."

The legal obligation with respect to human rights is thus noted by Philip C. Jessup, former Member of the International Court of Justice: "It is already law at least for members of the Untied Nations, that respect for human dignity and fundamental human rights is obligatory. The duty is imposed by the Charter, a treaty to which they are parties."

Certainly nothing is more basic to this obligation which the United States assumed when it ratified the U.N. Charter, than to outlaw mass murder of a national ethnic, racial or religious group, as such, whether committed in time of peace or war.

I have especially referred in this statement to the endless hearings through which this Committee has sat to emphasize the need to fish or cut bait. The Committee has certainly exhibited great courtesy as well as extreme patience over the years in allowing anyone and everyone to express his or her views on the subject. As it said in 1976, "further hearings on the treaty were not warranted in view of the voluminous record made in hearings in 1950, 1970 and 1971." There appears to be no provision in the Convention that would support a successful attack on constitutional grounds. *No objections asserted on a legal basis justifies {sic} delaying ratification. Any conceivable uncertainty as to a few phrases has been cured by the understandings. If there are justifiable reasons of national policy for not ratifying, they have not been advanced.* {italics added} The one new fact to be noted since the last hearing is the favorable action of the American Bar Association. And that has now been recorded.

74

Each time the Committee has acted it has reported the Convention favorably. *But each time it has reached the Senate floor, an actual or threatened filibuster has prevented the Senate from voting to support a commitment we made on December 9, 1948.* {italics added}.105

As Bitker pointed out, and as we wish to emphasize, If there were justifiable reasons of national policy for reservations and non-ratification, they were not advanced. We feel this means that rational and acceptable arguments against ratification did not emphasize the effect of ratification on the relationship between the Anglo-American ethny and U.S. minorities: that the anti-social contract prohibits such ratification without reservations and understandings, etc.. All constitutional-legal objections, however, such as the claim of constitutional incompatibility,106 the fear of subjection of U.S. citizens to foreign jurisdictions,107 the States Rights arguments, etc.108 had been dismissed by the unanimous opinion of competent experts called in by the Senate as being ungrounded and basically incorrect.

Furthermore, a special committee which was formed by President Nixon to investigate each of the objections raised by the Senate and report on them, issued a report refuting the legitimacy of each constitutional-legal objection raised by the senators.109 We therefore must raise the following question: if ratification would not have the illegal or harmful effect on American constitutional rights and guarantees which its opponents said it would, which the experts including the last six U.S. presidents confirmed that it would not, and if no justifiable reasons of national policy for not ratifying had been advanced, what explanation was there for such prolonged Senate reservation and opposition?

Capitalism and the Psycho-Social Value of Money

It appears that in any capitalist multi-national state in which the minority ethny is held in a state of oppression or domestic colonialism, the value of money seems always greater than in states where minority oppression is less or non-existent, or in states having a communist or social democratic system which provides for the basic needs.

The value of money seems to be greater because it carries, along with its nominal or use-value, a psycho-social value. That is, that money alone is able to provide the bearer with a greater social status, and thus greater psychic satisfaction, as well as the capacity to

get more done. This is simply because of the constant threat of starvation, illness and homelessness in which capitalist states maintain their national minorities (internal colonies). In the U.S., people are willing to do more for money than they would if they were not afraid of homelessness or starvation, etc.. Since money is the only barrier between self-maintenance and disaster for self and family, minority citizens of such capitalist states are forced to accept inhuman conditions side by side with conditions of plenitude, to feel (and consequently make it so) that money humanizes and lack of money dehumanizes. It is no wonder that in capitalist societies, the motivation to produce, increase output, etc. proves greater than in socialist societies.

One might ask whether the poor members of the majority ethny wouldn't suffer from the same effects if there were no oppressed national minorities (internal colonies). The answer is no. Because of racism and the existence of an anti-social contract between the rulers and ruled of this majority ethny, only vast numbers of the minority ethny can be so isolated from the political levers and opinion leaders of the system as to permit them to suffer to a politically significant degree even in times of plenitude without clear and imminent danger to the system in place.

Also, in multi-national states where minorities are oppressed, it serves not only the economic schema through simple economic exploitation, but also produces a constant psychological example for the eyes of the majority masses, making them fear what might happen to them if they do not cooperate politically or produce economically. At the same time, it puts the masses of the minority at the disposal of the entrepreneurs, large and small, of the majority for production usage, and alerts the masses of the oppressed minority to the knowledge that their very lives and social humanity depends upon their pleasing (for money) the majority ethny.

It is in this way that money in multi-national states has a greater value than money in socialist states: it can buy more, it can get more done, it gives a higher social status, and only it can bring (minimum) security. This is true simply because people will always be motivated to do more in order to avoid starvation or exposure than to have *extra* food or a *better* place to live. They are also inclined to give greater. respect and homage to those who can save their lives seemingly gratuitously by offering charity or employment than to those who offer the maintenance of an achieved security understood to be the right of all, provided through the social system.

Thus it appears that minority oppression in multi-national states offers the ruling elites a motivating tool for production and economic development. It is only when we ask: production to whose benefit? that we suggest an advantage of socialism. And this only seems true if we believe that the economic well-being of the majority supersedes or takes priority over technological development for the ruling elite, ie. economic development for the elite and for the sake of economic development.

White nationalism necessitates capitalism. After all, what use would the coming together in the "melting pot"of all the European races serve if there was not the freedom to exploit labour, to capitalize and consolidate the imperialist conquests of the past. Capitalism in the U.S. is not just an economic system to be debated, reformed or abandoned, but the historical *modus operandi* for benefiting from the national *raison'd'être*, white nationalism. Thus capitalism, like the other vehicles supporting white nationalism, is a crusading American religion, a religion similar to that in South Africa, a religion to which anyone wishing to survive in the U.S. quagmire must pay lip service.

Thus, there are fundamental elements in the U.S. anti-social contract that enable all other elements. They are: white nationalism, capitalism, and racism. White nationalism is the *raison d'être*, capitalism the *modus operandi*, and racism the catalyst and implementing agent.

The U.S. Constitution and Anti-Social Contract

This tree's leaf, illuminated from here the East
In its garden propagates
On its secret sense they feast
Such as sages elevate.

Is it but one thing single
Which as same itself divides?
Are there two which choose to mingle
So that one each other hides?

As the answer to such question
I have found a sense that's true:
Is it not this book's suggestion
That it's one and also two?

Forced Cultural Assimilation

Another important element of the anti-social contract is to provide the minorities with no option other than to culturally assimilate Anglo-American institutions and lifestyles in a situation of objective inequality and unequal status, thus assuring that the black or native Anglo-Americanized individuals emerging from this process will be integrated into the lowest social echelon of the Anglo-American nation. The result of such a strategy can be seen today in the modern multi-national state of India, where the ancient conquerors of India, the Aryan Hindus, hold the top echelon of a caste system while the conquered find their place in the lowest caste. We see the possibility now of African-Americans having the honor of being Hinduized -- becoming quite touchable Untouchables.[110]

The notion of the desirability of the assimilation of American minorities as individuals into the Anglo culture was stated most strikingly by Theodore Roosevelt with regard to Native Americans, in his Annual Message to Congress, 1901:

In my judgment the time has arrived when we should definitely make up our minds to recognize the Indian as an individual and not as a member of a tribe. The General Allotment Act is a mighty pulverizing engine to break up the tribal mass...We should now break up the tribal funds, doing for them what allotment does for the tribal lands; that is, they should be divided into individual holdings...The effort should be steadily to make the Indian work like any other man on his own ground. The marriage laws of the Indians should be made the same as those of the whites. In the schools the education should be elementary and largely industrial. The need of higher education among the Indians is very, very limited...[111]

However, while the Native Americans should be culturally assimilated, it is plain that, by the curtailment of their needed levels of higher education (according to Roosevelt), it was not anticipated that they should function in an equal status with other Americans. Similarly, in a speech to the Tuskegee Institute, Roosevelt outlined the education he felt appropriate for blacks:

...from the beginning Tuskegee has placed especial emphasis upon the training of men and women in agriculture, mechanics, and household duties. Training in these three fundamental directions does not embrace all that the negro, or any other race, needs, but it does cover in a very large degree the field in which the negro can at present do most for himself and be most helpful to his white neighbors...The professional and mercantile avenues to

success are overcrowded; for the present the best chance of success
awaits the intelligent worker at some mechanical trade or on a farm...112

Today this same educational orientation is being prescribed for the
African-American.

The masses who are to form the American underclass will
include the minority middle classes insofar as for the most part their
employment relates to servicing and managing the African-American
masses, although they will of course be at the top of the underclass,
and in such a position will share significantly in the fruit of the exploita-
tion. The genius of this system is that the payoff to the black middle
class for managing the programs of exploitation and oppression of
the minority masses serves not only as a sufficient incentive to keep
them happy with their "professional" jobs, but it also blinds them to
their position as the top layer of the underclass, serving as a window-
dressing to hide the more brutal conditions and suffering of the
minority masses.

The U.S. program of forced cultural assimilation has been institu-
tionalized as a part of the anti-social contract, and operates
automatically through all U.S. institutions to stifle the developing self-
awareness of the minorities and their movements towards self-
determination. Even many of the radical (socialist) groups in the U.S.
see the ultimate solution to the U.S. "racist problem" as arriving when
everyone turns tan. They amazingly overlook the fact that the U.S.
situation is essentially one of social and economic exploitation while
racism (fear of other) is only a tool to maintain the exploitability of vari-
ous populations. Thousands of years ago in India, part of the Aryan
conquering population as well as the conquered black population
turned tan, and now we find black and tan untouchables. The point
being that such policies only act to expand the numbers of the
oppressed available for exploitation.

This solution is no solution at all because it misses the entire
essence of the domestic imperialistic problem. The fact is that
increasing the number of the oppressed does not eliminate the
oppression. The fact that the oppressor group becomes smaller may
indeed serve to increase the economic stability of the oppressor,
etc.. Those who would support a solution as silly as this deserve no
further attention.

Do U.S. minorities want to assimilate? When members of the
minority ruling elite are obliged to respond to the suggestion of
forced cultural assimilation of its minorities (such as on occasion in

reporting to the Human Rights Commission of the U.N.), they always side-step this suggestion by pointing out that in the U.S., all minorities want to assimilate because, after all, this is the American way. However, we suggest that this is not true, and we feel that the summary of our research field study conducted from 1978-89 can serve to support our position.

Apart from those organizations financed by the government or other Anglo-American and Jewish groups, and certain "professional" elements of the middle class, no African-American organization financed by the minority population has knowingly opted or is willing to knowingly opt for assimilation into the Anglo-American nation, and certainly not as its underclass -- in a manner similar to the incorporation of the Dalits or Black Untouchables of India into the lowest shudra class of Hinduism. But on the other hand, as elaborated in my book, *International Law and the Black Minority in the U.S.*, [113] those organizations which receive governmental financial support and legitimizing recognition have, from the time of Booker T. Washington's Tuskegee Institute (which received the blessing of Theodore Roosevelt) to the present, been those which sought the assimilation of African-Americans into the Anglo-American nation. This has historically been the most important task of the black bourgeois "professional", a task which they are well paid to perform.

We studied abstracts of the professed program of approximately 270 organizations of the African-American minority in the U.S.. Over 10% of these organizations were visited by the researcher in New York, Boston, Ithaca, Columbia, South Carolina, Washington, D.C., Syracuse, Denver, Atlanta, Detroit, Chicago, St. Petersburg, Miami, etc., over the years,1975-1989. Our written data sources were:

1. Margaret Fisk, Encyclopedia of Association, Vol.1, Gale Research Company, 1977;

2. Harry A. Ploski, The Negro Almanac: A Reference Work on the Afro-American, 3rd edition, The Bellwether Company, New York, 1976;

3. AFRAM Association Inc., Directory, National Black Organizations, Harlem, New York, 1982.

From the information given and/or by telephone contacts, visits or prior knowledge of the societies, we arranged them into three chief categories: assimilationist, non-assimilationist, and preference unknown. Organizations expressing a strong purpose related to cultural preservation, and/or political and/or cultural self-determination and/or the need for special measures (including affirmative action quotas) were classified as non-assimilationist.[114] Those expressing

an interest only in civil rights, improvement of living conditions and/or exclusively employment opportunities and/or social and/or political integration, etc., were classified as assimilationist. Other organizations whose preferences could not be determined from data studied or prior knowledge were classified as position unknown. Because of the large number of organizations whose membership was stated or listed as unknown, we were not able to make a valid population comparison. Also we found the written data sources too often obsolete or containing incorrect data for use in understanding the purposes and programs of minority organizations. Therefore we relied on written sources only for location of organizations for the purposes of personal contacts.

Also, in our contact with representatives, we often found it impossible to determine the actual programs of most of the social and political organizations, regardless of their stated aims. In general, most such organizations seem to be doing any and everything under the general label of 'helping the black man'. Their political and social programs in relation to their objectives were almost never consistent. Representatives we contacted were usually either extremely rude, extremely helpful, or vague and mysterious when pressed to define the relationship between what they were doing and stated objectives, or to explain how a certain political or social program was to assist the development of African-American equality. Some representatives such as one director of an Africana Institute, regardless of the questions we asked, continuously referred to the situation of the Bantu in South Africa and why it is important to support U.S. policy in that area; some did not have the time to discuss their programs analytically; still others became rude and questioned the right of the interviewer to pose such questions, while certain other groups equivocated.

The representative of the Black American Masons in Ithaca, New York, for example, mysteriously disappeared for a few days, then left a note in the writer's box. The question asked of this organization was if they favored a policy of assimilation for the African-American or some other solution. Representatives of the NAACP seem to be the only group which clearly favored this objective but they preferred to use the word integration because they felt that the word assimilation would not be popular among African-Americans. When this question was posed to the President of the Afro-American Student Association at one of the major northeastern universities, he appeared stymied, avoided contact with the researcher for six

months, only to reappear offering the researcher a book on socialism in America.

The difficult experience of the researcher in attempting a direct enquiry into group preferences led to the conclusion that group preferences within the African-American minority can best be obtained from the originally stated objectives of the organization concerned, plus an observation (over two years) of their activities, programs, stated preferences and intentions, since the actual programs of these organizations seem often to be a result of their environmentally thwarted inability to formulate policy in accordance with original objectives and their consequent pragmatism.[115] Also the fact that most of these organizations did not make clear distinction between a social and political program or majority and minority interest, made enquiry along conventional quantitative lines difficult.

Ironically, the organizations which were able to openly and most successfully, logically and consistently express their orientation, objectives and programs, were also the organizations which were most conservative or most radical. In interviews with the representative of the Republic of New Afrika in Washington, D.C., the various African-American muslim groups in Chicago, Detroit, Philadelphia, Atlanta, Boston, Baltimore and Washington, D.C., CORE in New York, the Black Panther Party in New York, the Hebrew Israelites in Chicago, the Organization of Afro-American Unity in Chicago, the African Socialist People's Party in Florida, the All African People's Revolutionary Party in Indiana, the Black United Front in Chicago, the UNIA in Chicago, the National Islamic Alliance in Chicago, etc., the researcher found these organizations to have little difficulty in presenting programs consistent with stated objectives. This was also true of the most clearly assimilationist groups: the NAACP, SCLC, the Urban League, etc...

Regardless of the confusion surrounding the actual program of the majority of the organizations used for this survey, the researcher in order to give additional significance to the results of this analysis, using library statistical data, was able to distinguish five general sub-categories into which the assimilationist, non-assimilationist and preference unknown organizations were classified. The sub-categories are: most important socio-political organizations (5 points); other socio-political organizations (4 points); socio-cultural organizations (3 points) ; professionally oriented organizations (2 points); and organizations with an economic orientation (1 point).

The following are data samples of organizations placed in each category and sub-category.

MOST IMPORTANT SOCIO-POLITICAL ORGANIZATIONS
(All organizations in this category were visited by the researcher for data, and were given a weight of 5 for the purposes of analysis).
 (a) Assimilationist:
 1. the N.A.A.C.P.
 2. the S.C.L.C.
 3. the Urban League,
 4. the Rainbow Coalition
 5. the National Alliance Third Party, etc.
The importance of these organizations rests not in the size of their membership but in the closeness of their relationship to the power structure, and consequently their general authority and popularity in the African-American community.
 (b) Non-Assimilationist:
 1. All African-American muslim organizations
 2. The African People's Socialist Party
 3. International Human Rights Association of American Minorities (IHRAAM)
 4. Black United Front
 5. All African People's Revolutionary Party
 6. Republic of New Afrika
 7. Congress on Racial Equality (CORE)
 8. Operation Push
 9. National Black Congressional Caucus
 10. American Indian Movement
 11. American Indian Defence of the Americas
The importance of these organizations derives from their large membership support in the African-American community, or in the case of IHRAAM, their international popularity and consequent authority within the African-American community. These organizations were also given a weight of 5.

Our analysis concluded with 102 points against assimilation, 50 points for and 36 points under no preference or preference unknown. These figures clearly indicate that the U.S. government, in insisting that the national minorities have opted for assimilation, is not correctly representing the expressed will of these minorities, but rather the expressed will of the minority element within these minorities that supports the position of the government.

Domestic Colonialism

Being an integral part of the British Empire, and indeed of a world in which the colonization and oppression of African and Asian peoples was an accepted fact, the U.S. concept of universal equality and freedom was born "moribund" under the yoke of African-American enslavement and its unholy war to dispossess or extermi-nate the Native Americans. However, the insistence of the British educated elites of the original 13 colonies on presenting their country as an enlightened democracy posed for them the proble-matic of how to subject the African and Native American populations to a form of colonialism that would permit them to share the same terri-torial state, and at the same time create this state as a democracy in which all men could be said to be equal. This paradox of heightened democratic freedom existing in a country where the practices of slav-ery and genocide were occurring -- this problem was never really solved. Instead, it led to the creation of a type of anti-social contract that would serve as an institutional model for domestic colonialism.

This view of the U.S. orientation suggests that since the advent of the modern multi-national state, the formation of the anti-social contract is used to create situations of domestic colonialism in areas such as the U.S., South Africa, Latin America, Israel, etc.. This internal imperialism ideally targeted at visible minorities is most clearly seen when we compare the relationship between the state's ruling majority and its national minorities to that of the ideal model of the social contract, or to the principles of international law, as we have attempted to do in this book.

By viewing domestic colonialism in terms of the nature of the relationship between the ruling majority and its national minorities (ie. does it include significant degrees of domination, unequal exchange, and inequality) we can establish an empirical yardstick for determining when domestic colonialism exists. Such measurement may also provide the politico-legal basis for determining when the right of self-determination or political independence should be recognized and encouraged in international law. The only counter argument is that steps cannot be taken to bring about relational equality between the majority and minority because there is something fundamentally wrong with the minority. This, of course, would be nothing more than the use of racism in order to avoid moving to change a system that offers advantages to the majority.

In the case of such a statistical comparison in relation to the Anglo and African-Americans, the following is an abbreviated example of the type of statistical data that may be used to discover the degree of inequality, etc., and whether the system, as is, favors the majority ethny:

a) Median income for African-Americans was 57.1% that of Anglo-Americans in 1987.

b) In 1984 the median net worth of African-American households was just $3,397, *nine percent* of the average Anglo-American household.

c) In 1980, 55 percent of all African-American babies were born to unwed mothers; 11 percent of Anglo-American babies were born to unwed mothers.

d) In 1983, the imprisonment rate was 713 for African-Americans compared to 114 for Anglo-Americans. This means that an African-American is six times more likely to go to prison than an Anglo-American.

e) In 1972, only 1 percent of elected officials were African-American.[116]

What's more, the situation of the African-Americans is getting worse, particularly if one considers statistically the position of the newest generation to achieve adulthood. In 1973 the median income of African-American males 20 to 24 years old was $10,369. But the figure for this group in 1984 (adjusted for inflation) fell 44 percent to $5,768. At the same time, the proportion of these men with no reported income soared from 8 percent to 20 percent. The proportion of high school dropouts jumped from 14 percent to 43 percent. In 1973, 55 percent of African-Americans earned enough money to support a family of three above the government's poverty line. By 1984, only 23 percent could do so. The number of African-American children in one-parent homes whose parent had never married soared from 29 percent in 1980 to 54 percent in 1988.[117]

Most data surveyed suggests that there is a distinct and well-established inequality between the standing of the Anglo-American majority in relation to the minorities, and that this inequality has consistently existed over time. Thus, there seems to exist empirical evidence to support the proposition that internal economic imperialism and domestic colonialism do exist in the U.S.. We feel that further research in this direction could establish the existence of domestic colonialism beyond the shadow of a doubt.

Our view of colonialism does not require a separation between the concept of classical colonialism wherein the governor occupied a separate territory from the colonized, and the more subtle form wherein the governing nationality and the colonized nationality occupy the same territorial state. Obviously by putting emphasis on measurable relational variables instead of the present emphasis in international law on territorial separation and past history, all conflicts among nations or nationalities can be brought under the same principles governing the right to self-determination, thus encouraging more just relations among nationalities living within the same territorial states, while better providing for solutions under international law.

However, we should nonetheless draw attention to new territorial alignments within the American national territory itself which facilitate relational inequality, perhaps indicative of the re-institution, inside America, of the classical colonial concept involving territorial separation. Recent experiments in allowing the decaying cities of the U.S. to become predominantly African-American while the state and socio-economic institutions of the city remain under the political dominance of the suburban Anglo-American is a relatively new development, and when coupled with the notion of "special economic zones", it appears that for various reasons, the ruling elites have opted for more territorial separation and visible internal colonies. Is this to provide new political opening for the ever-developing consciousness of the African-American bourgeois managerial classes, a separate political arena for the demands of the new African-American political class? If so, it represents a greater recognition by the Anglo-Americans of the existence of internal colonies.

In a recent article in *The New Republic*, Morton Kondrache writes of the African-American "underclass" that inhabit the heart of these new territorially separate zones (cities):

> It is hard to say how big it is, since statistical definitions of it are highly arbitrary. By one *geographical* {italics added} definition, it's estimated that about 2.5 million people live in the most poverty-ridden census tracts of U.S. industrial cities. By one income definition, it's estimated that about four million blacks have lived for ten years below the poverty line. A slightly larger number, 4.5 million, lived in 1987 in families that could be termed "the poorest of the poor" -- with an income below $4,528, half the poverty level.[118]

Charles Wagley and Marvin Harris, in *Minorities in the New World*, point out that:

...in the larger and newer cities of the south, where the effects of industriali-
zation and urbanization have made it difficult to adhere to the letter of
traditional racial etiquette, and in practically every Northern city, where both
the legal fabric of discrimination and the main body of racial etiquette are
absent, residential segregation is the main key to *caste* {italics added}
restrictions. In these Northern cities, such as Chicago and New York, most
of the Negroes are found in a few tightly packed, sharply delimited areas.
These ghetto-like neighborhoods are usually filled with sub-standard dwell-
ings and are afflicted with all the evils of big-city slums. Unlike the
inhabitants of white slum areas, however, *many people in these Negro "cities
within cities" are financially capable of living in decent lower-middle-class or
even upper-middle-class neighborhoods. They are prevented from moving,
however, by widespread restrictive policies maintained by white property
owners.* {italics added}.119

This existing condition suggests that the factor of class or
economic income does not offset the factor of nationality. America is
not an assimilated society in which African-Americans "happen" to
form the lowest economic subdivision, but rather a society in which
domestic colonialism is in place, which has historically victimized the
U.S. minorities.

In the past, political independence of a pre-defined national
territory -- or the creation of one -- solved the dilemma of open conflict
caused by territorial colonialism by annulling the anti-social contract
(removing the oppressed from under the direct political control of the
oppressor) and in so doing, suggesting that the oppressed were
now empowered and thereby responsible for their own needs. But
the problem itself may have been simply the nature of the anti-social
contract, not necessarily the need for political independence. *This
understanding becomes more important in cases of domestic coloni-
alism such as that in the U.S., where the possibility of political
independence may be neither necessary or desirable.* It would
appear that in a world growing technologically and culturally smaller
and smaller, in a world that seeks some form of political unity through
the United Nations, the preface to international peace and world unity
requires a closer and more open examination of the nature of the
associations between citizens and their governments, between
minority nationalities and majority nationalities, as well as between
states.

The present high level of international minority conflicts within
multi-national states is a testimony to the fact that the continuous
separation in international law and relations between the problem of

nationalities in multi-national states and those in previous colonial empires, as it relates to the right to self-determination, serves no useful purpose, and creates a situation where the eye can no longer see where the foot must step, believing that nations cease to exist simply because they are within the same political entity, and thereby misleading multi-national states down the wrong road, eventually to stumble, fall and break into many pieces -- pieces that, in many cases, were not desired by either party to the dispute, pieces which will have even greater difficulty relating and cooperating with each other even as nation-states, pieces that must for economic and military reasons seek new alliances -- all acting to maintain the international system in a weak and unstable condition.

CONCLUSION

In 1776 the ruling elites of the 13 original colonies came together in Philadelphia to compose a written social contract between the state to be and the developing Anglo-American ethny: the U.S. Constitution. Nowhere in this document was African-American enslavement or Native American dispossession (the most horrible affronts to the notion of freedom it so gloriously advocated), dealt with. This is true although these minorities together at the time formed the majority of population over which this Constitution was to govern. If it had been, such a Constitution surely would not have been acceptable to the Anglo-Americans themselves. Thus, its acceptance under the condition of such omissions logically implied that the freedom and equality promised in this document need not necessarily include the African and Native American portion of the population. It therefore implied that they were to be governed according to a different set of rules and norms -- the rules and norms of the anti-social contract: extermination, slavery, then segregation, and now socio-economic oppression in self-managed internal areas (internal colonies).

The U.S. Constitution was most remarkable for its hypocrisy in purporting to uphold human rights without forbidding African enslavement and Native dispossession. Modern historians have chosen, even with hindsight, to view this document as representing a threshold in mankind's search for democracy, and have implicitly and explicitly chosen to ignore the simultaneous occurrence of the most destructive human holocaust of modern times as not a salient variable in their analysis. Why? Because the humans involved were not English or European. Suppose the Germans or Irish had been enslaved in the U.S.. Would we today be celebrating the U.S. Constitution as bringing about a state representing mankind's search for freedom and equality? The sheer arrogance and uncompromising hypocrisy of the persistent celebration of the framers of the U.S. constitution as men seeking liberty for mankind, should only provoke amazement.

We are fully aware of the excellent historical traditions of democracy (concurrent with slavery and colonial empire) that were incorporated in the U.S. Constitution (from Rome, Greece, Britain, etc.), and we realize that the formal document called the U.S. Constitution is an example englobing the ideals of democracy in 1776, but so too are the documents called the Constitution of South Africa, and the more recent Constitution of India. No doubt the formal document of the U.S. Constitution calls for the democratic freedom of all men, but its siamese twin, the anti-social contract calls for white nationalism, for people with white skins to unite in order to maintain exclusive access to the awesome U.S. power and politico-economic machine built on the land of the Native Americans and backs of the African-Americans, so that they, like microbes, could grow strong on the misery of their fellow countrymen. Like the U.S. classification of Puerto-Rican immigrants to the U.S. of the same family and same household into different races, it has no respect for other traditions or social realities. It proposes to create a world of black and white, of bad and good, losers and winners.

The anti-social contract that lies latent in every U.S. ideal and institution is immediately activated once that ideal or institution is exposed to use by a U.S. minority. If in any way the minority wishes to use same for the purpose of producing equal status relations between the Anglo-Saxonized majority and the minority, it not only short circuits the normal operations of the ideal or institution, but it also acts to injure the minority individual or group that sought its use.

As demonstrated in the first section of this book, the anti-social contract by no means represents the western egalitarian tradition of humanity and freedom and democratic government for which Europe is so rightly admired, nor does it represent any similar English traditions. Rather it is unique to the mentality, experiences, economic needs and demands of those Europeans who left Europe to claim and settle in lands already occupied by non-European populations. In the U.S., one must emphasize the unique experience of being slave-masters, and naturally the world perspective and philosophic orientation that such an experience is likely to produce.

Also of importance is the fact that many of these special Europeans soon to become Americans left for adventure and profit, abandoning not only country, but friends and family as well. Their ideology of white nationalism even led them to abandon their children if both parents were not of European descent. They were unique even in relation to Europe, and to the class from which they

came, and their settler's experience solidified this uniqueness. Putting their white skin aside for a moment, which of course is absolutely forbidden, these people, these settlers, these warriors against the existence of the Native American, these slave masters, these seekers of gold, these nomads ever moving westward, were to become an entirely new Anglicized European race: the Anglo-Americans.

All this is particularly true for the U.S. because many socio-political ties with England were soon broken and almost the entire population was in direct contact, during most of its formative years, with African enslavement, the continuous war against the Native Americans, and the influx of all races of European immigrants. Contradictory duality of culture (one emanating from the interactions on the slave plantation and "melting pot", the other from the institutions imported from Europe) was exceedingly marked. While lip service was forever paid to the imported institutions, including Christianity, the pragmatic management of a plantation that required the forced enslavement of many African nations, provided the necessity for less acceptable and often hidden plantation pragmatism and folk culture to determine how the imported institutions and European ideals and traditions were to be actually interpreted and internalized.

Of course the settlers (whether in the U.S. or South Africa), in order to be acceptable, particularly to Europe with which they wished to identify, always dressed their plantation pragmatism and culture in the finest garments of European Christian liberal civilization. However, their real philosophic orientation always provided the reasons why they should continue to take all of the land for themselves through force and extermination, and why they should continue their conquest of Indian land, and why they should continue to enslave the Africans. Much of the philosophical basis for the colonists' counter-ideals no doubt was influenced by the orientation in Europe towards non-Europeans, but slavery and extermination of fellow countrymen could only find their emotional, psycho-social and philosophical support in philosophical deviations necessitated by the conditions of their daily life. Europe could have shared their arrogance and ignorance of others, but it could not share their daily experience.

In short, Anglo-Americans flattered themselves with notions of European libertarian and egalitarian ideals, all the while using these ideals to mask and to justify the primitive savagery that their real behavior had become. They had a continuous need for European

good will that would assure access to its technology and skills to maintain their ascendancy over the local non-European populations. And of course, they required European collaboration to maintain their domination over the indigenous populations. These populations had to be isolated from any possible alliance with various competing European powers.

We should not overlook the ending of slavery in the West Indies, and the British efforts to force the Americans to do the same, the occasional alliances of the French and Spanish with certain Native American populations, the constant threat posed by this possibility, the desire of Canadians to remain loyal to the Crown, and the ever pressing need for immigration, etc.. Although inspired by the success of the U.S. model, the *pieds noir* in Algeria and the South African whites, not having completed the process before the period of decolonization and European awareness (particularly in communist Russia) of the bankruptcy of colonialism, were caught in the act.

When we realize that the vast majority of the poor, homeless, imprisoned, drug-addicted, inadequately fed, and non-medically protected persons in the U.S. belong to the American minorities, the full historical impact of the anti-social contract becomes apparent. We observe the minority self-managed city (special economic zone) surrounded by the sea of Anglo-Americans who provide and control the professional, business and service industries in these desolated cities while living in highly developed and aesthetically pleasing surrounding areas. We see the new internal colonial areas becoming physically visible, and we understand that the settlers' buccaneer mentality is triumphant and the U.S. anti-social contract is in no danger of becoming obsolete.

The socio-political and economic forces put at the disposal of this gamut of U.S. intellectual mythology has tended to control the way U.S. scholars, teachers, news media, government, etc. approach the question of minority rights and oppression, and guides them along lines of inquiry that can only end in re-inforcing the system as is, as well as reinforcing adherence to the very myths that block free and sincere dialogue. The result of all this is the general maintenance of the anti-social contract, and the suppression of the voices and energy of those (non-addicted to American mythology) whose ideas and energy are so badly needed to fuel minority and future U.S. socio-political and economic development.

The socio-political and economic liberation of Africa and Asia is already in full gear, and already there are changed relations between

Europe and the U.S.. Europe is becoming less dependent on the U.S. and its dream of white nationalism. As Europe moves towards becoming effectively economically unified and an independent socio-economic power in itself, Europe no longer needs U.S. white nationalism in order to galvanize its skills, talents and resources. The rise of other states of socio-economic and/or political power, such as China, Japan, Iran, Libya, Saudi Arabia, Cuba, Brazil, the Soviet Union, etc.., means that the U.S. anti-social contract which in the past has so elegantly served U.S. demographic, military, socio-economic and political interest, now stands diametrically opposed to these same interests.

Today, with the Anglo-Americans having achieved a secure position at the top of the totem pole, the U.S. white nationalism offers special benefits to a larger population of many of the same types that left Europe years ago in search of gold and the freedom to exploit. What some of today's immigrants have in common with immigrants in the past is their desire not simply to obtain reasonably-paid employment, but to benefit inordinately, and consequently their belief that the American minorities should stay in their present position, that U.S. white nationalism is great to the extent that it benefits them. They are the buccaneers, the rogues of the 20th century. The only difference today is that they come from a spectrum of various nationalities.

Along with the internationalization of investment opportunities, the exploitability of the U.S. minorities has been internationalized. Now all capitalists can share in the booty derived from the earlier enslavement and disenfranchisement. International capitalism and white nationalism have joined hands. The motto of the new colonists is "The victim is to blame." Like the shudra cast in India, they have often been assigned the position of middlemen (particular businessmen, professors in the political and international studies programs of African-American universities, etc..) In positions of such importance to the politico-eocnomic awareness of the minorities, they can be depended on to foster white American superiority and dominance or frustrate the African-American struggle for self-determination by clearly supporting the institutions in place. They tend to despise the minorities not only for being politically ignorant, but also for being poor and for wanting to resist their oppression. Their effectiveness as managers of the system in place is so great that large areas and institutions have been turned over to their management, in cooperation and collaboration with the Anglo-ized African-American middle

classes. The extent to which the in-flow of these types is encouraged by the Anglo-American ruling elite suggests that this elite may no longer see the U.S. as its home preserve, on the one hand a country for continual development where it pays to act in such a manner as to eventually bring about long-term solutions to socio-cultural and economic problems, or on the other, a country to maintain their dominance through prolonged promotion of white nationalism. Rather, is it not possible that the highly developed U.S. capitalist elites have begun to detach themselves from a sense of their own U.S. nationality, moving instead towards the notion of an international white nationalist ruling capitalist class, and leaving its rainbow-colored intermediates in the domestic U.S. to oversee the new U.S. cities (internal colonies)?

If this is not the case, then if the U.S. is to maintain a strong position in the world and a healthy domestic internal development the anti-social contract must be overcome and a process of restructuration including compensation and restitution for minorities who suffer from gross past violations of their human rights, must begin. Europe has found a new, more socially acceptable, satisfying and stimulating future in contractual integration of its national units and social democracy. Israel and South Africa may still have stars in their eyes but they can hardly be seen as the best type of bedpartners for the U.S., while Japan, once itself a colonial power, then enemy, is now as an ally and major economic competitor.

Today all European countries have rejected and turned away from the belief in the barbaric settlement of lands occupied by non-European populations, and the enslavement or extermination of their populations for the sole benefit of European settlers. This is true although the socio-economic benefits of white nationalism may remain a central inspiration for some of the ex-Cuban, ex-Yugoslavian and other ex-eastern European defectors who continue to leave their countries and families to belatedly seek their slice of the American Dream pie, at the expense of the misery, dislocation and even homelessness of U.S. minorities, and indeed at the expense of the oppressed of the world.

It is often noted by African-Americans that whenever U.S. influence in a country or among a sector of its population becomes dominant, that country or sector not only becomes pro-American -- it also becomes anti-black. In Caribbean or African countries, such sectors become anti-African-American. So what does American democracy really mean to these sectors?

The U.S. anti-social contract, once successfully established, has acquired an awesome economic, military and political power of its own to popularize and enforce its orientation. It has created a society which, though the greatest producer of food in the world, will not or cannot feed its hungry; which has the technology to construct millions of homes at the drop of a hat, but cannot or will not house its homeless; that sends men to the moon and spaceships to the outer reaches of the solar system, but cannot or will not provide adequate public transportation for its elderly. A society that prides itself in breakthroughs in psychology and sociology, but sends it minorities to prison at unequal rates of 100 to 1; that owns and operates the majority of great businesses and enterprises in the world, but cannot or will not provide full employment for its own university graduates; that boasts the highest medical technology in the world, but cannot or will not provide adequate medical care for more than half its population, etc..

To the extent that America persists in remaining captive to its own myths, and blind to its own realities, there can be no hope for it to wake up to the demands of the modern world in relation to national minorities. Indeed, there is the possibility that the bitterness and contradictions engendered by the long and seemingly unending anti-social contract coupled with the emergence of new non-European adversary states will serve to push the U.S. into a situation of prolonged crisis and conflict from which it might never fully recover.

Where can we turn for a remedy? We would point, as examples, to the many modes of solution to majority/minority conflict developed from the experiences of other peoples worldwide, and to the recommendations in international law, of which these experiences form a part.

Our concern is that the disease be recognized, so that the cure can begin, for at this historical moment (according to the highest democratic moral ideals of western civilization), the decision of many African-Americans and other national minorities to support, abide by and indeed praise the societal laws and institutions of the U.S., is a favor. It is not their duty. The decision of others not to do so, may be their right.[120] More than two centuries of trying to eliminate the many grave ramifications of this moral dilemma while continuing to ignore its root cause, serves as convincing evidence that denial of the anti-social contract is no solution and that ignorance of its existence is no excuse.

With a strong determination and great power, most things are possible, but some things are not. It is very unlikely that minority oppression in the U.S. can be routinized to the extent that the sparks remaining cannot, under severe economic conditions, re-ignite the flame.

The solution to minority undevelopment and the consequent deterioation of U.S. cities, etc., lies in enabling those minority groups and leaders who have demonstrated their ability to transform minority members and conditions, rather than those presently in power who (by the continuous deterioration of these conditions) have proved that they cannot help and thus merely depend on the pro-forced-assimilation and anti-African-American recognition bias of the system, to maintain their position. To do this will require major shifts in the way politico-eocnomic benefits are distributed among the minorities. A useful discussion of the problemmatic calls for future research on *ending the anti-social contract.*

FOOTNOTES

[1] Allan Bloom, *The Closing of the American Mind,* Simon and Schuster, New York, 1987, pp. 32, 160, 162.

[2] The word minorities is used within the context of its present international-legal definition. See Y. N. Kly, *International Law and the Black Minority in the U.S.,* Clarity Press, Atlanta, 1985. This is true although it is being applied to subjects of colonial empires The political separation of the concept of subjects of colonial empires from that of national minorities probably resulted from the obvious political advantage of not mixing the problem of minorities (colonial subjects) territorially separated from their rulers with the problem of national minorities who occupied the same national territory as their rulers. If we also remember that the former, having acquired the means to make war, posed a serious problem for world peace, while the latter never rose above the barrier of being problems for the internal affairs of states, we may easily imagine how and why the political necessity propelled the international legal orientation towards a solution based on territorial right to political independence instead of acceptance of the much less acceptable and politically explosive right of minorities to self-determination or political independence.

[3] The fact that the U.S. model is successfully held up as a successful way of dealing with minorities while at the same time it admits that its chief minorities always remain behind the majority ethny in a situation of domination and inequality, and are thus opened to exploitation, serves to convince other states that by copying the U.S. model, they can successfully practice domestic colonialism in relation to their minorities without negative consequences, since the U.S. has perfected and made this unspoken form of colonialism internationally acceptable.

[4] In the Islamic doctrine both the governed and the civil power are to be subject to God's will. Thus the legitimacy of the civil power depends on its submission to the call of God as understood through the Shariah, Islamic law, etc..

[5] Allan Bloom, *The Closing of the American Mind, op. cit.,* p. 161.

[6] Jean-Jacques Rousseau, *Emile,* edited by Bloom, Basic Books, New York, pp. 39-40.

[7] Jean-Jacques Rousseau, *Du Contrat Social,* edited by R..G.Schwart- zenberg, Editions Seghers, Paris, 1971, p. 45.

[8] *Ibid,* p. 51.

[9] See Y. N. Kly, *International Law and the Black Minority in the U.S.*, Clarity Press, Atlanta, 1985.

[10] *Ibid*, p. 58.

[11] *Ibid*, p. 105.

[12] *Ibid.*, p. 108.

[13] *Ibid.*, p. 108.

[14] *Ibid.*, p. 106.

[15] *Ibid.*, p. 110.

[16] *Ibid.*, p. 110.

[17] *Ibid.*, p. 111-113..

[18] *Ibid.*, p. 116, 119

[19] *Ibid.*, p. 120.

[20] *Ibid.*, p. 121. This interpretation cannot be directly inferred from any statement made by Rousseau, but by projecting his statements on page 121 into the modern situation, it is logical to assume he may have felt this way.

[21] *Ibid.*, p. 122.

[22] *Ibid.*, p. 125.

[23] *Ibid.*, p. 126.

[24] *Ibid.*, p. 129.

[25] *Ibid.*, p. 131.

[26] *Ibid.*, p. 133.

[27] *Ibid.*, p. 134.

[28] *Ibid.*, p. 135.

[29] *Ibid.*, p. 136.

[30] *Ibid.*, p. 138.

[31] Note that this statement applies equally to Islamic as well as Christian states. In Christian states it is fairly well accepted that religion should not interfere with the interest of politics, while in the Islamic state it is well-established that politics should serve the interest of religion. (Note that by Islamic state, we do not refer to secular states which may have majority Muslim populations, but rather to those States which have accepted to be governed by the Shariah. In contemporary times, only the Islamic Republic of Iran so qualifies.)

[32] *Ibid.*, p. 144.

[33] *Ibid.*, p. 145.

[34] *Ibid.*, p. 154.

[35] *Ibid.*, p. 197.

36 *Ibid.,* p. 232.

37 *The Holy Quran.*

38 Abu Yusuf, *Kitab al-Kharaj,* (Persian translation), Calcutta, 1808, p. 71. Baladhuri, *Fuutuh-al-Buldan,* ed. M.J. De Goeje, Leiden: Brill, 1866, p. 162.

39 Abdullah Mustafa al Maraghi, *Al-Tashri al-Islam Li-Ghairil Muslimin* (Islamic Legislation for non-Muslims), Cairo, n.d., p. 64.

40 Ibn Hisham, *Sirat-al-Rasul,* Vol. I, pp. 175-178. "The Jews of Bani Awf make a community with the faithful," *Ibid..*

41 *Ibid.*

42 Muhammad Hamidullah, *Al-Watha'iq al-Siyasiyyah* (Political Documents), Ciaro: 1956, pp. 111-112; Abu Yusuf, *op. cit.,* pp. 72-73; Baladhuri, *op. cit.,* p. 65; Philip K. Hitti, *The Origin of the Islamic State,* New York: 1916, pp. 101-102.

43 Abu Yusuf, *op. cit.,* p. 70.

44 *Ibid.,* p. 85.

45 Baladhura, *Futuh al-Buldan,* pp. 437-438; Sayyid Muhammad Masun, *Tarikh-i-Masumi,* Bombay: 1938, pp. 26-29; I.H. Qureshi, *The Administration of the Sultanate of Delhi,* p. 3.

46 Abu Yusuf, *Kitab al-Kharaq,* p. 70.

47 M. Hamidullah, *Muslim Conduct of State,* Lahore: 1945, p. 106.

48 *The Holy Quran:* 5:44-45.

49 *Hidaya,* Voll. II, p. 1040; Abu Yusuf, *op. cit.,* p. 85.

50 Hamidullah, *op. cit.,* p. 108.

51 Abu Yusuf, *op. cit.,* p. 16.

52 Tabari, vol. VII, pp. 2014-2015.

53 The author wishes to give credit to Nasim Hasan Shah, "The Concept of Al-Dimmah and the Rights and Duties of Dhimmis in an Islamic State," *Journal: Institute of Muslim Minority Affairs,* Vol. 9:2, July 1988, p. 217, from which much of the above was taken.

54 See Lawrence Ziring, "Constitutionalism and the Qur'an in the Final Decades of the 20th Century," *Journal: Institute of Muslim Minority Affairs,* Vol. 9:2, July 1988.

55 See *International Law and the Black Minority in the U.S., op. cit..*

56 Charles A. Beard, *New Basic History of the United States,* Doubleday & Company, Inc., New York, 1944, p. 33.

57 Charles M. Andrews, *Colonial Period of American History,* Yale University Press, Princeton, 1934, pp. 56-7.

58 Howard Zinn, *A People's History of the United States,* Harper, New York,

1980, p. 49.

59 Amaury de Riencourt, *The American Empire,* Delta, New York, 1968, pp. 8-9.

60 *Ibid.,* p. 16.

61 Howard Zinn, *op. cit.,* pp. 47-9.

62 *Ibid.,* p. 36.

63 *Ibid.,* p. 36.

64 Thomas R. Hietala, *Manifest Design: Anxious Aggrandizement in Late Jacksonian America,* Cornell University Press, Ithaca, 1985.

65 *Ibid.,* pp. 10-11.

66 de Riencourt, *op. cit.,* p. 13.

67 Hietala, *op. cit.,* p. 133.

68 Zinn, *op. cit.,* p. 321.

69 Beard, *op. cit.,* p. 394.

70 J.C. Furnas, *The Americans; A Social History of the United States: 1587 - 1914,* G. P. Putnams Sons, New York, 1969, p. 84.

71 *Ibid. , p. 86.*

72 From the Annual Message to Congress, 1905. *Messages and Papers,* XI, 1165-66.

73 Beard, *op. cit.,* p. 282.

74 Furnas, *op. cit.,* p.86.

75 Zinn, *op. cit.,* p. 373.

76 Beard, *op. cit.,* p. 211.

77 *Ibid,* p. 212.

78 From observation of population statistics, it appeared that the logic emanating from the anti-social contract called for a maximum of about 30% African-American population in each of the Southern States. Only Mississippi seems to have not yet achieved this goal.

79 Jan Nederveen Pieterse, *White on Black: Images of Blacks in Western Popular Culture,* Royal Tropical Institute, Amsterdam, 1989.

80 Ali A. Mazrui, *The Satanic Verses or a Satanic Novel? The moral Dilemas of the Rushdie Affair,* The Committee of Muslim Scholars and Leaders of North America, Greenpoint, N.Y., 1989.

81 de Riencourt, *op. cit.,* pp.45.

82 Bloom, *op. cit.,* p. 26.

83 Philip Hewett, *On Being a Unitarian,* Canadian Unitarian Council, Toronto, 1982.

84 Hietala, *op. cit.,* pp. 136-37.

85 *Ibid.*, p. 135.

86 Thomas C. Cochran, *Social Change in America; The Twentieth Century,* Harper & Row, New York, 1972, p. 31.

87 Henry F. May, *Ideas, Faiths & Feelings: Essays on American Intellectual & Religious History, 1952-1982,* Oxford University Press, New York, 1983, p. 164.

88 *Ibid.*, p. 169.

89 *Ibid.*, p. 177.

90 See Part II of *International Law and the Black Minority in the U.S., op. cit..*

91 Prepared by the author from data presented by the Black Law Caucus, Cornell University Law School, Ithaca, N.Y., 1977. Details on these cases can be found in *Race, Racism and American Law* by Derrick Bell (Tommie Smith and John Carlos, Mexico City, 1968).

92 Dr. Rayford and Phillip Sterling, *Four Who Took Freedom* , Doubleday and Company, Garden City, N.J., 1967, p. 65.

93 Any liberalization of minority rights has traditionally been conceived to have a greater impact in the conservative U.S. south and south west. In both these areas, original minorities often form significant portions of the population.

94 See Y. N. Kly, *International Law and the U.S. Human Rights Foreign Policy,* National Archives, Ottawa, Canada, 1979. The argument of the Senate against human rights treaties must also be viewed in relation to the fact that U.S. courts are open to international law. See Freiedmann, W., Lissitzyn, Oliver J. and Pugh, Richard C., *International Law: Cases and Materials,* West Publishing Co., St. Paul, 1969, pp. 100-58.

95 Here we refer particularly to the Covenant on Civil and Political Liberties and the Convention on the Punishment of the Crime of Genocide, both of which the U.S. played a major role in creating.

96 Senator Sparkman, Republican from Alabama and Chairman of the Senate Committee on Foreign Relations, opposed reporting the treaties to the Senate floor for a full vote.

97 Erades and Gould, *International Law and Municipal Law: in the Netherlands and in the United States,* Leyden -A.W. Sythoff, Oceana Publications, New York, 1961, pp. 34-49.

98 National interest has been accepted in U.S. courts as legitimate reason for domestic non-involvement with a principle of international law. While this conept (the act of state doctrine) is immediately and legally concerned with court interference in the executive power over foreign policy, it nevertheless implies that international law which has a potential political effect on the U.S. view of the collective rights of its minorities as conceived of as part of the

national interest may be ignored or rejected. See *International Law: Cases and Material, op. cit.,* pp. 100-158.

99. Harold Isaacs, "Race and Color in World Affairs," in George Shepherd, Jr., *Racial Influences on American Foreign Policy,* Basic Books Inc., New York, 1970, p. 38.

100 *Ibid.,* p. 38.

101 Executive O. 81st Congress, first session, March 22, 1977, p. 17.

102 Hearings before the sub-committee of the Committee on Foreign Relations, United States Senate, Ninety-fifth Congress, U.S. Government Printing Office, May 24 and 26, 1977, pp. 79, 91-544, 57-1190 and 87-211.

103 *Ibid.,* p. 112.

104 It is a well-known fact that in the U.S. the key committees of the Senate have been controlled by Southern conservatives.

105 Senate Executive Report No. 93-5, 93rd Congress, first session, Government Printing Office, Washington, D.C., 1977.

106 Some senators expressed the belief that the treaties contradict certain aspects of the U.S. Constitution.

107 Some senators expressed the fear that ratification of the major human rights treaties would open the door to U.S. citizens being subject to stand trial before non-U.S. courts.

108 The States rights argument suggests that ratification would usurp the power assigned to the states by the Constitution. See also Hearing before the Sub-Commission of the Committee on Foreign Relations, U.S. Senate, 95th Congress, March 4 and 7, 1977; 94th Congress, 2nd Session, April 29, 1976; 95th Congress, 1st Session, May 24 and 26, 1977, U.S. Government Printing Office, 91-544, 57-1190 and 87-211. It is only in relation to the Genocide Convention that a full and favorable constitutional study has been submitted to the Senate.

109 A report in support of the Treaty Making Power of the U.S. in Human Rights Matters was prepared by the Special Committee of lawyers of the President's Commission for observance of human rights, years 1968 October 1969.

110 See V. T. Rajshekar, *Dalit: The Black Untouchables of India,* Clarity Press, Atlanta, 1987.

111 William H. Harbaugh, *The Writings of Theodore Roosevelt,* Bobbs-Merrill, New York, 1987, p. 219.

112 *Ibid.,* p. 200.

113 *International Law and the Black Minority in the U.S., op. cit..*

114 This criterion follows that used by the Sub-Commission to determine if a group desires assimilation or qualifies for minority status. See U.N. docu-

ments E/CN.4/Sub.2/384/Add. 6 and E/CN.4/Sub.2/384/Add.5.

115 Here we refer to doing anything that their environmental circumstances will permit in order to maintain the existence of the organization, including the employment and social status that it affords. The most striking example of this was the organization called "The Blackman's Volunteer Army of Liberation (BVAL)". This organization was founded in 1968 in the heyday of the riots or insurrections. It went on to operate on the social level to fight drug addiction in the community.

116 Statistics taken from the following sources: Morton M. Kondracke, :The Two Black Americas, " *The New Republic,* February 1, 1989, pp. 17-20; Steven Whitman, "The Crime of Black Imprisonment," *Chicago Tribune,* May 17, 1987.

117 Chauncey Bailey, "African-American Leaders Face a Crisis," *Detroit News,* April 17, 1989.

118 Kondrache, *op. cit.,* p. 18.

119 Charles Wagley and Marvin Harris, *Minorities in the New World,* Columbia Uniersity Press, New York, 1968, pp. 143-44.

120 Note that we speak of moral right, not legal right. Thus the exercise of such a moral right can lead to punishment by force or imprisonment, and all of the consequences that this entails. However, the fact that minority prison population is disproportioantely higher suggests that they do not feel the same moral duty to follow the laws that Anglo-Americans do. Thus, this is meant to broaden our understanding of what is happening in our country. Our concern is that the disease be recognized so that a cure can begin.